MW00633252

THE LOST JEWISH COMMUNITY
of the West Side Flats
1882–1962

March 25, 2002
12 Nissan 5762

The Jewish Community Relations Council of Minnesota and the Dakotas is proud
and honored to lend its 501(c)3 non-profit status to sponsor the publication of
"The Lost Jewish Community of St. Paul—The West Side Flats 1882–1962"
by Gene H. Rosenblum.

The histories about St. Paul's diverse communities have only been partially told.
Vibrant Jewish neighborhoods—like the West Side—have stories that need to be
told in order to record the challenges and achievements of the early Jewish
immigrants.

We look forward to the publication and distribution of this important work.

Sincerely,

Stephen R. Silberfarb
Executive Director

VOICES OF AMERICA

THE LOST JEWISH COMMUNITY
of the West Side Flats
1882–1962

Gene H. Rosenblum

ARCADIA

Published by Arcadia Publishing,
an imprint of Tempus Publishing, Inc.
3047 N. Lincoln Ave., Suite 410
Chicago, IL 60657

Printed in Great Britain.

Library of Congress Catalog Card Number: 2002105030

For all general information contact Arcadia Publishing at:
Telephone 843-853-2070
Fax 843-853-0044
E-Mail sales@arcadiapublishing.com

For customer service and orders:
Toll-Free 1-888-313-2665

Visit us on the internet at http://www.arcadiapublishing.com

Contents

About the Author

This is Gene H. Rosenblum's second book published by Arcadia Publishing. His first book was the acclaimed *Jewish Pioneers of St. Paul: 1849-1874* published in 2001.

Gene H. Rosenblum is a retired St. Paul, Minnesota real estate attorney. He has a B.A. from the University of Minnesota and a J.D. from the William Mitchell College of Law (formerly St. Paul College of Law).

He has served as an Assistant to the Mayor of St. Paul, and Assistant Corporation Counsel for the City of St. Paul. He has served two terms on the St. Paul Heritage Preservation Commission. He also has been "of counsel" to the Attorney General of the State of Minnesota.

He is a past president of the Ira Weil Jeffrey Lodge of B'nai B'rith, and a former Treasurer and member of the Board of Governors of the old District Six B'nai B'rith.

He is one of the founders of the Jewish Historical Society of the Upper Midwest and served on its board several years. He is also past president of the "B'nai B'rith Rochester Chaplaincy" at the Mayo Clinic in Rochester, Minnesota. He also has served on the board of the Temple of Aaron congregation.

Before writing his first book for Arcadia Publishing, he had written various articles for the Jewish Digest and the American Jewish World. He has also written of Judge Isaac Nunez Cardozo in an article called "Western Grandee" published by the Western States Jewish History Association in California.

He is married, and has two children, one grandson and five great-grandsons.

Introduction

This is a story about the "West Side Flats," or sometimes called the Lower West Side of St. Paul, in the state of Minnesota. It is a true story about the "lost Jewish community" of an area that stretches from the Mississippi River banks to the cliffs of the "West Side Hills," covering approximately 320 acres of flat, sandy land.

The families are gone, the houses are gone, the streets are gone, and the synagogues are gone. All fell victim to the vagaries of the Mississippi River and "urban renewal." You can visit New York City's Lower East Side, Chicago's Maxwell Street, or even Baltimore, Maryland, where you won't find a community so completely obliterated as St. Paul's West Side Flats, now known as Riverview Industrial Park. I never lived on the West Side Flats, but my grandparents did. My maternal grandparents (the Weiners or Winers) lived at 109 Eva Street, near the banks of the Mississippi River, for a few years until they moved up to the "Capitol Heights" area, or what we called "Fourteenth Street" in the eastern shadow of the Minnesota State Capitol.

My paternal grandparents (the Rosenbloom, Rosenblom, or Rosenblums) settled at 126 State Street at the beginning of the 20th century, then moved to 271 Kentucky Street, and finally 234 East Fairfield. They remained there until the end of the First World War, when they moved into the "Hill District" near Selby and Dale, close to the Temple of Aaron Synagogue located on Ashland and Grotto Streets.

The West Side Flats are now but a memory to a whole generation. It was lively and interesting and colorful, not unlike the Lower East Side of New York City or Maxwell Street in Chicago.

I hope that you will enjoy this pictorial trip down Memory Lane.

> "Snatch our memory from oblivion…"
> —Rabbi Irving Greenberg, Washington, D.C.

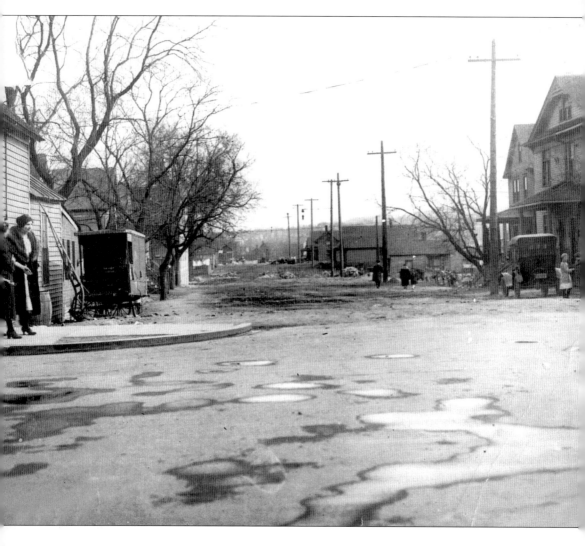

This photo shows a view of Indiana Street looking down Robertson, which was unpaved. On the right is the Neighborhood House. (Courtesy of the Jewish Historical Society of the Upper Midwest.)

Acknowledgments

When I prepared the manuscript for my first book, *Jewish Pioneers of St. Paul: 1849-1874*, which was published last year, I was struck by the fact that the so-called Jewish community of St. Paul actually consisted of four different communities: (1) the community established by the German-Jewish refugees, who organized the Mt. Zion Temple and who were largely pioneers; (2) the community established by the Polish-Eastern European Jews who arrived between 1871 and 1882, who organized the Sons of Jacob Synagogue in downtown St. Paul, which was adjacent to, yet very different from, the Mt. Zion community; (3) the community established by the Russian and Eastern-European refugees who fled to the United States beginning in 1882 and settled on the West Side Flats; and (4) the small community established east of and around the Minnesota State Capitol in an area called Fourteenth Street.

My first book dealt with the pioneering German and Polish Jews who settled in the downtown area of St. Paul. Most of the manuscript was composed in 1978 as part of an unsuccessful application to the National Endowment for the Humanities, and most of the pictures were from the Minnesota Historical Society and the Ramsey County Historical Society.

This, my second book, is devoted to the history of the now-vanished Jewish community of the West Side Flats, located south of downtown and on the west bank of the Mississippi River. I am very grateful to Dr. Linda Schloff of the Jewish Historical Society of the Upper Midwest for many of the pictures used in this book. I am also grateful to Tom Lewin (Rhoda's husband), who used modern scanning equipment to provide publishable copies of the pictures from the archives of the Jewish Historical Society of the Upper Midwest. I am also grateful to Bonnie Wilson and the staff of the Minnesota Historical Society, who provided me with copies of photos from their archives. I am also very thankful for the contributions of the many private individuals who shared their photographs with me.

For source material, the late Bill Hoffman, author of at least four books on his memories of living on the West Side Flats, was extremely valuable. Rabbi Gunther Plaut's book on "The Jews of Minnesota" provided much background information on the arrival of the desperate refugees in 1882. The many other sources listed in my Bibliography filled in a lot

of holes and allowed me to get a better perspective for the background material.

A Master's thesis by Lorraine Esterly Pierce entitled "St. Paul's Lower West Side," published in 1971 at the University of Minnesota, while not a major source of material, served as an excellent guide to the information I had already acquired. I want to thank Thomas Shaughnessy of the University of Minnesota library for providing me with a copy of Ms. Pierce's thesis.

Finally, I want to thank Donald Boxmeyer of the *St. Paul Dispatch-Pioneer Press* for providing me with copies of his special columns on the West Side Flats, and Elsie Nienaber of the American Jewish Archives, who provided me with pictures and material to help me understand some of the history of the area. The staff at the Highland Park Branch of the St. Paul Library helped me find resource books. Charles Rodgers of the Minnesota Historical Society provided me with materials on the history of the St. Paul schools located on the West Side Flats. Jane Steinman and Warren Steiner of the Mt. Zion Temple provided me with pictures from their archives, including photographs of the old synagogue buildings on "the Flats."

Last, but not least, I am especially grateful to Steve Silberfarb, Executive Director of the Jewish Community Relations Council of Minnesota and the Dakotas (JCRC), who without hesitation provided the support necessary for my book to reach publication.

This book also would never have to come about without the help and support of my wife, Nancy, who edited the manuscript and gave me very valuable advice on the use of the pictures.

I.
In the Beginning

The so-called "West Side Flats" was initially a flat piece of sandy land on the west bank of the Mississippi River, lying south of and across from downtown St. Paul, Minnesota. As such, it was part of Thomas Jefferson's Louisiana Purchase in 1803. Today, it would be technically defined by the United States government as a "flood plain."

Geologically, the edges of the limestone strata along Dayton's Bluff and the West Side Bluffs, which bordered on the Mississippi River, were ground smooth during the glacial period and polished by the sliding of icebergs on their way down from the North. During that period, the Mississippi River was not the river of today, but a wide stream that flowed from bluff to bluff. (1)

When the icebergs retreated, they left a flattened area full of silt and sand, and a much reduced Mississippi River. The river eventually became the boundary between Ramsey County and Dakota County.

In 1849, as the population of St. Paul grew, it became necessary to create some means of transportation between the two counties separated by the Mississippi River. The original method of travel, the use of a dugout canoe, would no longer suffice.

A bill was introduced in the Minnesota Territorial Legislature to grant a charter to one Isaac N. Goodhue "to keep and maintain a ferry boat across the Mississippi River opposite the Lower Landing in St. Paul." (2) The bill did not pass and Goodhue and his brother applied to the Ramsey County Commissioners for a ferry charter across the river. The license was granted in 1850, and the ferry soon plied the waters for those that needed to cross between the two counties. (3)

St. Paul's West Side, as part of Dakota County, was originally Spanish territory, but until 1851 had been occupied by the Mdewakanten Sioux Indians. That year, George W.H. Bell filed a land claim for the 320 acre area east of the West Side Bluffs, near what became State Street. (4)

In 1854, the Territorial Legislature passed an act to incorporate the "St. Paul Bridge," later called the Wabasha Street Bridge, in order to provide a form of transportation better

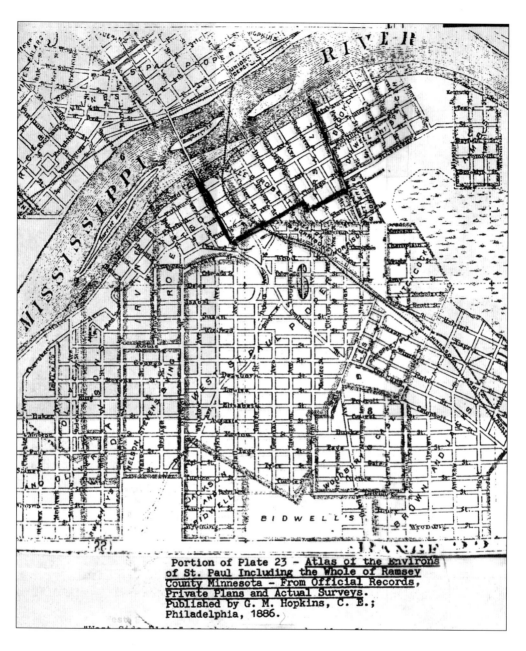

Portion of Plate 23 – Atlas of the Environs
of St. Paul Including the Whole of Ramsey
County Minnesota – From Official Records,
Private Plans and Actual Surveys.
Published by G. M. Hopkins, C. E.;
Philadelphia, 1886.

"West Side Flats" as shown shortly after being annexed to the city of St. Paul and before most of the streets in the former West St. Paul were renamed.

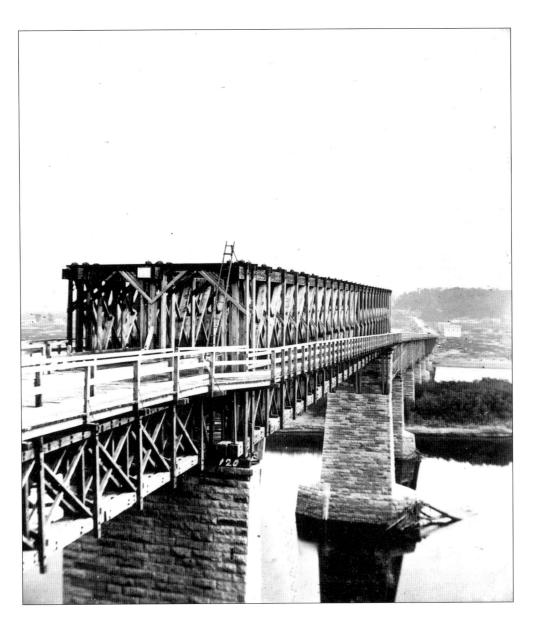

This view looking south is of the original St. Paul Bridge, the city's first bridge across the Mississippi River. It was completed in 1857, replacing a ferry boat operated by Isaac N. Goodhue and serving as a toll bridge until 1874 when this part West St. Paul was annexed to the City of St. Paul. It was later renamed the Wabasha Street Bridge. (Courtesy of the Minnesota Historical Society, photo by William H. Illingworth.)

than that of the Goodhue ferry. Construction of the bridge commenced in 1856. On September 3, 1857, the St. Paul City Council subscribed $50,000 in bonds, provided by proceeds from toll charges, in order to complete the bridge before winter set in. (5)

When the bridge was completed, it provided the needed transportation for merchants and other residents who were willing to pay its toll charge. When the bridge became opened, it allowed a trickle of Irish and German immigration to West St. Paul. By the winter of 1874, it became apparent that St. Paul wanted to acquire an additional 2,800 acres to expand, and several bills were introduced into the Minnesota Legislature. (6)

The Legislature responded and it authorized an election to be held to change the county lines and allow the city of St. Paul to annex the area. The election was held, and 4,700 votes approved a change of county lines and annexation of the West Side area, then known as West St. Paul, while 53 votes opposed the change. (Note: the city of West St. Paul, a separate corporate entity, exists today in Dakota County and should not be confused with the West Side.)

One of the first benefits of the annexation vote was the addition of 2,800 acres to the city of St. Paul. Another benefit was the abolition of the toll system on the bridge between the two areas. On November 4, 1874, a rebuilt Wabasha Street Bridge (formerly the St. Paul Bridge) was opened for free use. (7) Until the construction of the Robert Street Bridge in 1886, it was to be the only means of transportation between the two counties.

Included in the annexed area was about 230 acres of meadow and swamp, which was initially used as a hog dump and was later converted to the St. Paul Municipal Airport (first called Holman Field). There were no flood walls and the area repeatedly flooded over the years.

II.

The Refugees

On March 13, 1881, Czar Alexander II of Russia was assassinated, and suddenly all of the Jews in Russia were in danger. His successor, Alexander III, initiated policies of expulsion and pogroms that turned Jewish life in Russia into a nightmare. (8)

The Jews had been in Russia since the eighth century B.C., even before the Russian tribes. (9) In the sixth century B.C., after the Jews were expelled by the Babylonians, a second wave of Jewish exiles headed for Russia. (10) Six hundred years after the destruction of Jerusalem by the Romans in the first century A.D., a third wave of Jewish exiles settled in Russia. The Jews had also been in Poland as early as the ninth century B.C. (11)

Now they had to leave, abandoning their little homes and synagogues, and run for their lives. The enactment of the May Laws of 1882 triggered a mass exodus, and over three million Jews were to leave for America throughout the following forty years. (12) They came as families, and even as entire villages and towns.

Down the gang planks they came, confused, injured, and insulted at every turn. The Jewish refugee agencies were desperate. They settled them in New York City in the area of the Lower East Side, on Delancy Street. They sent them to Chicago, and they settled along Maxwell Street. In early 1882, the first group of two hundred refugees arrived in St. Paul, Minnesota. (13)

Somehow they would be provided for. It was no small effort to do so, as the number of refugees exceeded the then entire Jewish population of St. Paul. The Jewish community of early St. Paul consisted mainly of German Jews that had fled Germany after the fall of Napoleon, and some English, French, Hungarian, Austrian, and Alsace-Lorraine Jews. (14)

In July, 1882, an additional 35 arrived, and than another 200 on July 14, 1882. (15) They came on the eve of the Sabbath, without food or money, with only the clothing on their backs. There was no shelter to see them through the Sabbath. No one had been warned of their arrival.

It was not a question of providing them work. What they required were the basics of food and shelter. The St. Paul city officials did what they could. (16) The refugees were so

hungry that when two hundred loaves of bread were provided, a mob scene ensued, as no orderly distribution plans had been made.

The ladies of the Mount Zion Temple did what they could to help those in need. Rabbi Wechsler and Mrs. Julius Austrian went to the Mayor and the Chamber of Commerce. The daily newspapers made a plea to the public for clothing and work. (17) Never before had the Jewish population of St. Paul been required to make such a request for their fellow Jews.

The refugees were housed in the Railroad Immigrant House on Third and Broadway Streets. No one spoke English. The Rabbi's wife and her friends went down and cooked meals for the refugees, one fourth of whom were children. The Jewish leaders met at the Standard Club and subscribed additional funds. The St. Paul City Council provided funds.

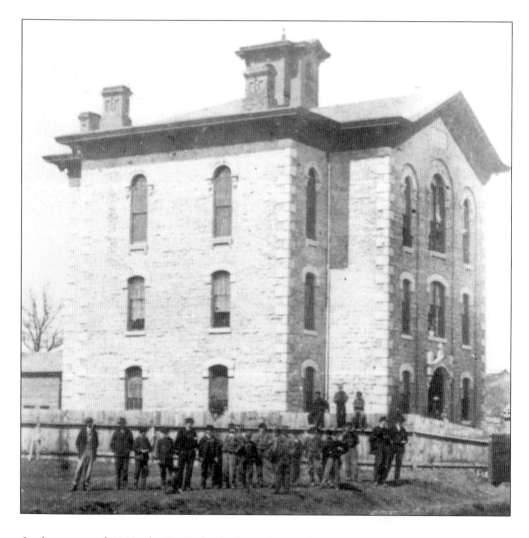

In the summer of 1882, the St. Paul School Board made the old Franklin School located east of the Minnesota State Capitol available for the use of housing and processing the several hundred Russian and Eastern-European Jewish refugees that had suddenly arrived in St. Paul. (Courtesy of the Minnesota Historical Society Library.)

Rabbi Judah Wechsler of Mount Zion Synagogue led the battle to help the settlement of the refugees from Russia, Lithuania and Poland in 1882. He and Mrs. Julius Austrian went to the Mayor's office and the Chamber of Commerce to raise funds for the refugees' care and shelter. (Courtesy of the Minnesota Historical Society.)

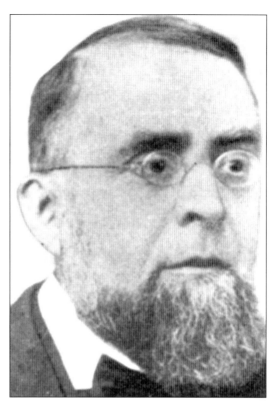

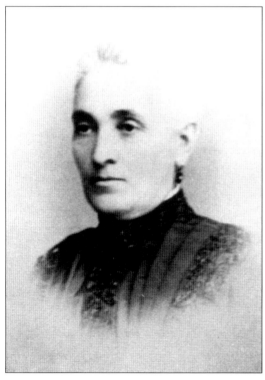

Mrs. Julius Austrian joined Rabbi Judah Wechsler of Mount Zion Synagogue to plead for funds to settle the Jewish refugees that had suddenly arrived from Eastern Europe and Russia. Mrs. Austrian, along with Rabbi Wechsler's wife and other members of the Hebrew Ladies Benevolent Society, did all that they could and cooked meals for hungry refugees. (Courtesy of the Wisconsin Historical Society.)

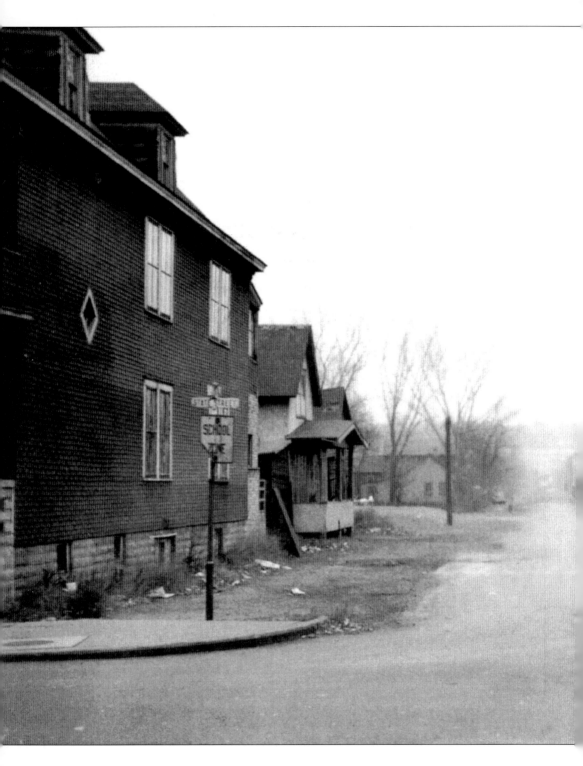

This photo shows the intersection of State Street and Texas Avenue, which was where most of the early refugees settled after arriving in 1882. On the near right, with the pillars can be seen the "Texas Avenue Shul," the

Chevra Misinas Askinas synagogue at 284 Texas Avenue. While State Street was paved, many of the side streets, including Texas Avenue, were not. (Courtesy of the Jewish Historical Society of the Upper Midwest.)

From the Railroad Immigrant House they were moved to the Franklin School in the Capitol Heights area around Fourteenth Street. (18) After basic hygienic needs had been met and clothing provided, the children were given haircuts, much to the chagrin of their parents. Biblical law among the Orthodox Jews was being violated, the adults thought, and after all their travails, here they were having their children's hair cut. What could get worse?

The German Jews looked on with incredulity, as their Russian brothers arrived in such a desperate state. The Russian Jews looked on with equal incredulity, at the well-groomed, clean-shaven, English-speaking German Jews and wondered if they were, indeed, bona fide Jews. (19)

The mere thought of these Russian immigrants becoming a ghetto transplant in St. Paul sent shivers of fright down the well-groomed backs of the existing German-Jewish population. Something had to be done. These Russian Jews had to be dispersed throughout the land, educated in American ways, and integrated into society. (20)

Soon thereafter, the then small city of Minneapolis, as well as other small communities, saw their first Jewish settlers as the refugees were dispersed. A number of the refugees settled in the near North Side of Minneapolis. Eleven Jews were sent to Cable, Wisconsin; nine went to Crookston, Minnesota; and six went to a farm in Wells, Minnesota. (21)

In St. Paul, some 40 were settled in around the Sons of Jacob synagogue on Tenth and Robert Streets; some remained in the Capitol Heights area around Fourteenth Street; some went to the near East Side; and approximately 20 were settled on the West Side Flats. (22) The Flats were still quite sparsely settled, and some of the refugees moving into the area used their carpentry skills to build themselves small frame homes, without basements. Others moved into homes vacated by the Germans.

In the 1884-1885 City Directory, the following were shown to be living on the West Side Flats as the first Jewish residents: David L. Cohen, Eleazar Cohen, Samuel Goldstein, Aaron Margules, Herman Rosenbaum, Isaac Katz, Simon Ruthenberg, Harris Eppstein, Penequist Kantorowitz, Simon Ettinger, Solomon Abraham, Max Oranstein, Joseph Stein, Nathan Silberstein, Isaac Edlowitz, and David Harwitz. There were probably more. They were all engaged in peddling; traveling about the area acquiring and selling whatever goods and materials they could as the only means of income to feed their families. (23)

Eventually, they were absorbed into the labor market, obscurely buried in grocery stores, candy shops, tailor shops, "mom and pop" stores, cigar makers, pants pressers, and dealers in junk. (24)

Little did the German-Jewish community of St. Paul suspect that within one generation, the children of these Russian Jews would spark a period of Jewish Enlightenment, and that within two generations, the Russian Jews and their offspring would wrest control from them in the general community. These new immigrants on the West Side Flats had absorbed the older Jewish settlers of Eastern Europe and were now a force to be dealt with.

Although many families had migrated together, those that were left behind were never out of the minds of the first refugees. They immediately began to save their money, and loans for $300 were obtained to provide for steamship tickets for their loved ones.

III.

State Street
and all the other funny little streets

After the City of St. Paul had annexed what was then called West St. Paul, and which would become the West Side, in 1874, the city fathers were faced with the task of connecting the two areas. The old St. Paul (Wabasha Street) Bridge was removed and rebuilt. With the reconstruction of the Wabasha Street Bridge, they then also faced the task of reviewing the street names to make sure none were duplicated. (25)

The 2,800-acre area of the old West St. Paul had been previously developed and platted with streets and blocks, and street names were given by each individual developer. It was possible to have duplicate names within blocks of each other and this would cause confusion and make it difficult to settle the new area and make it impossible for business to flourish.

The early occupants of West St. Paul were of French, Spanish, and German origin. The early street names either reflected these origins or, for the sake of simplicity, were merely given the letters of the alphabet or numbers such as First Street, Second Street, Third Street and so forth.

After some study, the St. Paul City Council began a comprehensive, decade-long re-naming of streets in the new West Side area.

State Street was originally named "A" Street. It was a wide, ribbon-stretching road, arrow straight from the banks of the Mississippi River at Water Street, bringing the West Side Flats and the West Side Hills together. (26) In 1883, the City Council renamed it State Street. (27)

Eventually, State Street, which ran North and South, was paved and became the main thoroughfare. The majority of the refugees settled along this street after the Robert Street Bridge was completed in 1886.

They flowed across the Wabasha and Robert Street Bridges so that by 1910, it was estimated that over 70 percent of the population of the West Side Flats was Jewish. State Street became the place for the refugees to settle. (28) The earliest refugees had settled at the corner of State and Texas Streets.

They built their first major synagogue and established their first small businesses there.

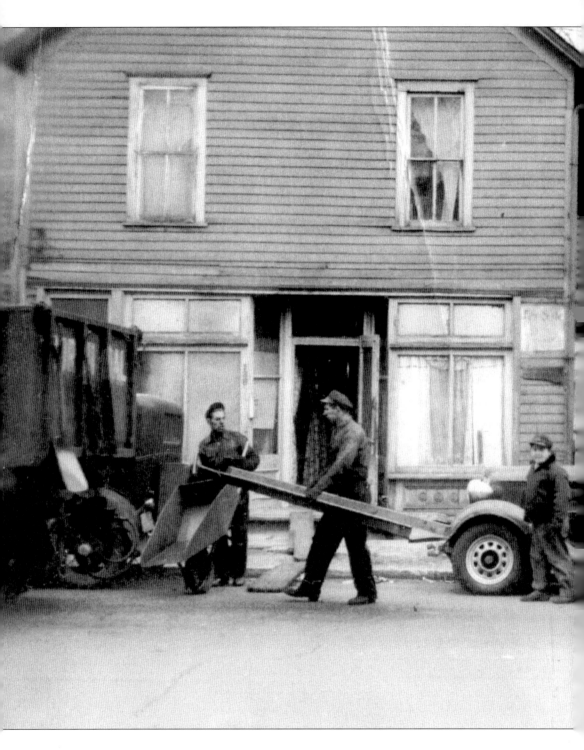

Gershon's Hardware Store, owned by Gershon Abromovich, is shown on State Street near East Fairfield. Shown is a truck unloading coal for the winter season. Gershon's was not only a hardware and general merchandise store, but also a place to buy steamship tickets for relatives back in the "old country," to have

papers notarized, and to have letters translated. This building eventually burned to the ground. (Courtesy of the Jewish Historical Society of the Upper Midwest.)

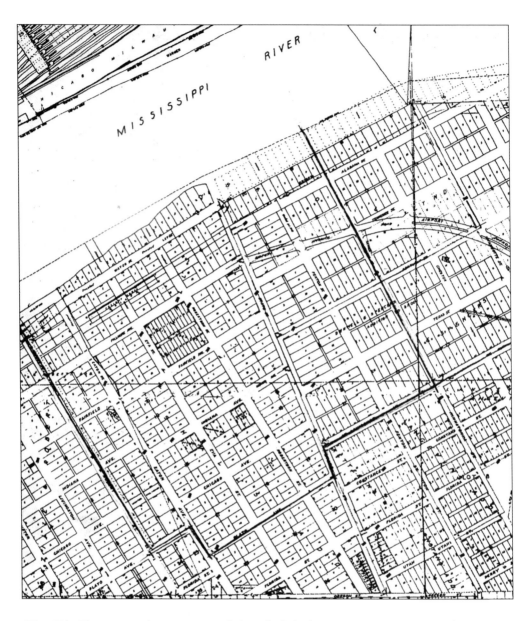

West Side Flats area as shown in 1960, before all of the houses, stores, synagogues, and streets were completely obliterated by the creation of the "Riverview Industrial Park." (Courtesy of Carson Map Company.)

Old sway-back mares pulled hundreds of wagons through the street, and children rode the backs of the horses rather than riding behind them, as the children of German Jews had done.

Every Halloween, all of the children—and even some of the adults—would be found tipping over "outhouses," that quaint early accommodation to sanitary planning, as a seasonal prank. (30) Smearing candle wax on windows and other harmless little pranks occupied their time on this American holiday, and old buggies often ended up on the rooftop of the outhouse and the outhouse ended up in the middle of State Street. (31)

Another street that became a major thoroughfare was Fairfield Avenue, which ran East and West. It was originally platted as Fifth Street and in 1886 gained its final name. It too soon accommodated many of the early refugees, and on it too some of the earliest synagogues were built. Pretty soon there was the "State Street Synagogue" and the "Fairfield Avenue Synagogue," even though they officially had more religious names.

Indiana Avenue was originally also platted as Fifth Street in old West St. Paul, and running parallel with Fairfield became another main thoroughfare. It was one of the first streets to be renamed in 1876. (32) It also became home to the first "Neighborhood House," established by the German Jews at Mount Zion Synagogue, for a place to Americanize and train the early settlers. (33)

All the other little streets upon which the refugees settled and that comprised the West Side Flats ran perpendicular to these main thoroughfares. Texas, Eva, Tennessee, Eaton, Minnetonka, Chicago, Plato, Robertson, St. Lawrence, Fenton, Alabama and Fillmore soon accommodated the Jewish refugees. The two other major streets that stretched into downtown St. Paul from the West Side and along which the refugees scattered were South Robert Street and South Wabasha Street. (34)

Texas Avenue had originally been named Second Street, while Eva was "C" Street, Tennessee was Third Street, Eaton was Herman Street, Minnetonka was Pickerel Street, Chicago was Seventh Street, Plato was Eighth Street, St. Lawrence was Sixth Street, Fenton was "B" Street, Alabama was Second Street, and Fillmore was Fourth Street in old West St. Paul. (35)

Only State Street was eventually paved its full length, while Eva Street had been paved for only a short distance. After houses on streets adjoining the major thoroughfares had been built, the city would often dump dirt fill on the streets. As a result, homes already in existence would find themselves, with additional fills year after year, well below the street level, so that stairs would have to be constructed going down to the houses from the street level.

The streets where the dumpings of fill towered above the homes usually were Eva, Chicago, Eaton, and Plato Streets. When the sewers were finally installed in some of the streets, the city workers never bothered to pack down the existing dirt over the sewers. This left these dirt streets with a narrow spine-like hump running down the center of the entire length of the street. (36) Most of these little streets were mere footpaths to the homes and businesses built along them.

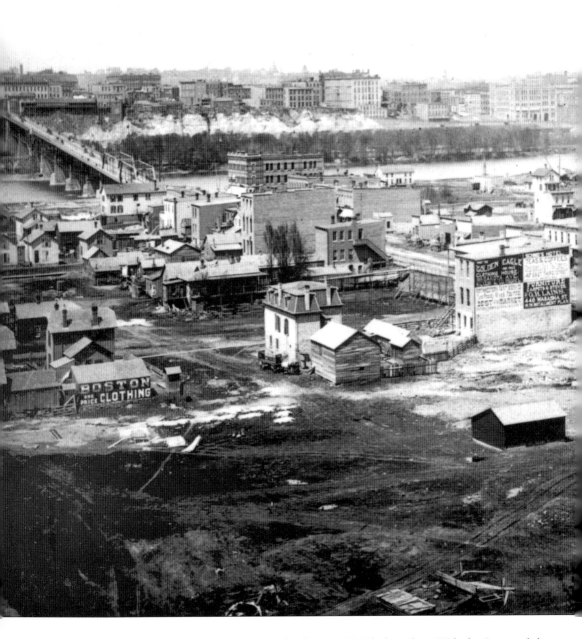

This photo by T.W. Ingersoll shows the West Side Flats in 1885, looking down Wabasha Street and the Wabasha Street Bridge towards downtown St. Paul. The Russian and Eastern-European Jewish refugees

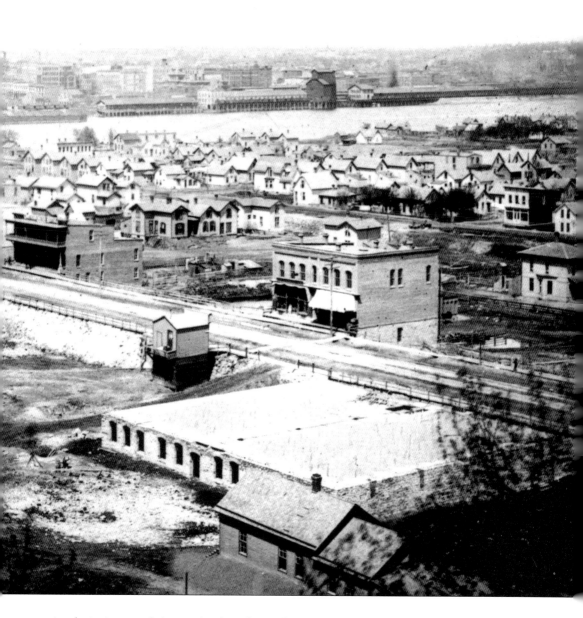

were just beginning to settle into modest frame homes that they had constructed. Wabasha was primarily a commercial street. (Courtesy of the Minnesota Historical Society.)

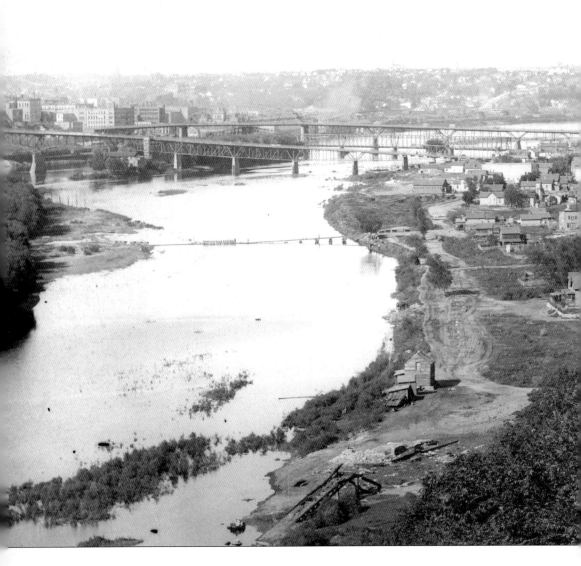

This view is of the West Side Flats looking down from the West Side Hills in 1888. In the background can be seen both the newly built Robert Street Bridge (1886) and the reconstructed Wabasha Street Bridge. In the foreground can be seen a railroad bridge across the Mississippi River. The railroad bridge, owned by

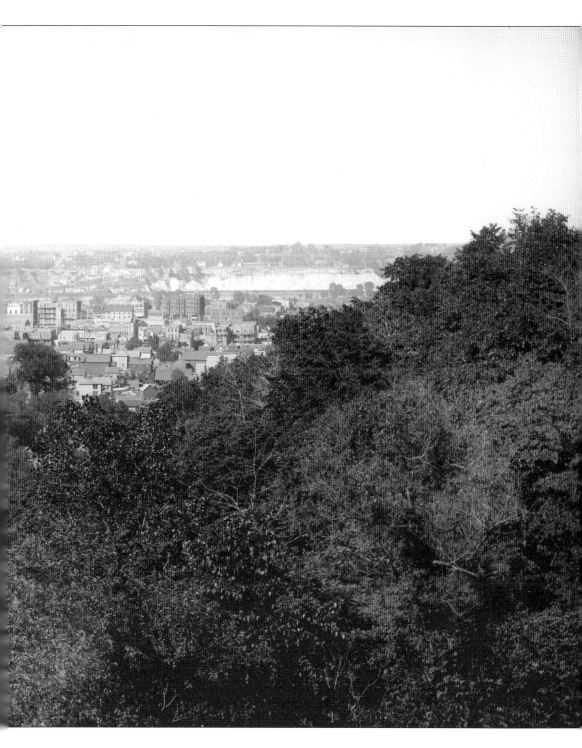

the Minnesota and Northwestern Railroad Company, was also completed in 1886, by moving large quantities of material from the Bluffs. (Courtesy of the Minnesota Historical Society.)

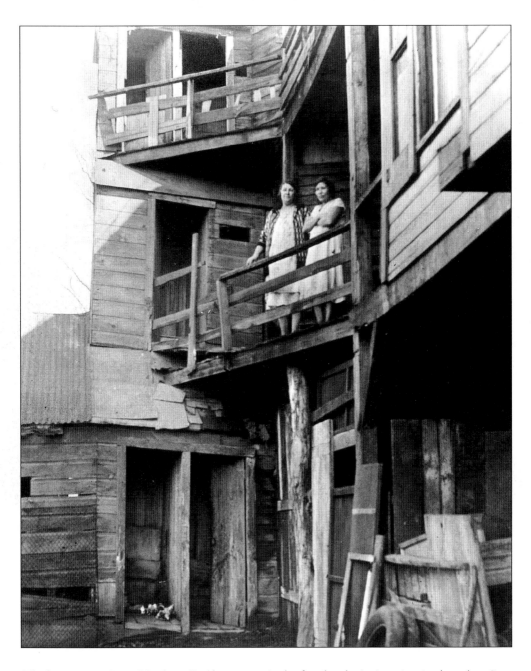

The famous State Street "Outhouse," a three-story miracle of modern hygienic engineering located on State Street just north of the railroad bridge, is shown here in 1940. Two of the "patrons" can be seen on the second floor of the "facility." (Courtesy of the Minnesota Historical Society, photo by the St. Paul Daily News *newspaper.)*

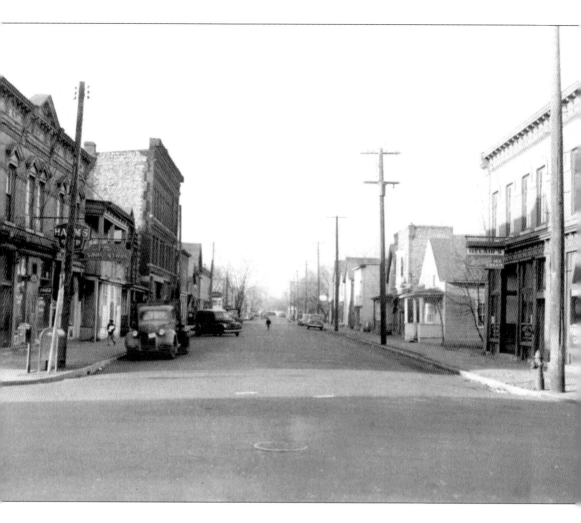

This photo shows the intersection of State Street and Fairfield Avenue in 1935. This was a main commercial intersection and Mintz's Shoe Store, a long time fixture of the West Side Flats, can be seen on the left. (Courtesy of the Jewish Historical Society of the Upper Midwest.)

Benjamin Gottlieb and Louis and Samuel Misel's scrap iron yard, located at 147 State Street, is shown here, as well as one of the many unpaved streets lying off State Street. (Courtesy of the Jewish Historical

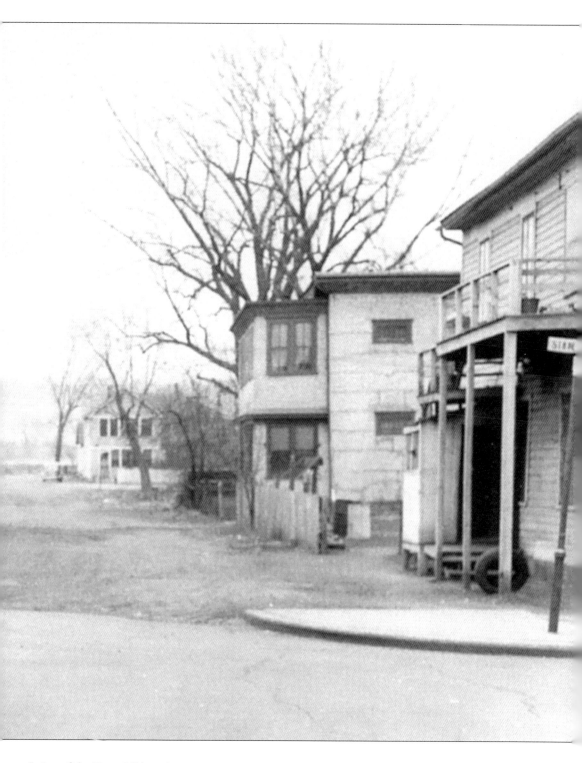

Society of the Upper Midwest.)

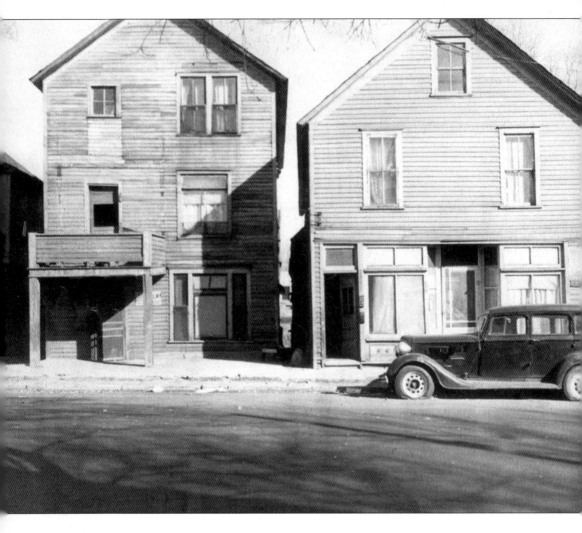

State Street not only contained small businesses, it had many large family homes too. Shown here on the left is one of the many Tankenoff family homes of the West Side Flats. (Courtesy of the Jewish Historical Society of the Upper Midwest.)

State Street had a mix of residences, both large and small. Shown here are two typical frame homes on State Street. (Courtesy of the Jewish Historical Society of the Upper Midwest.)

Large duplexes and smaller homes, as shown here, could often be found side by side on State Street. (Courtesy of the Jewish Historical Society of the Upper Midwest.)

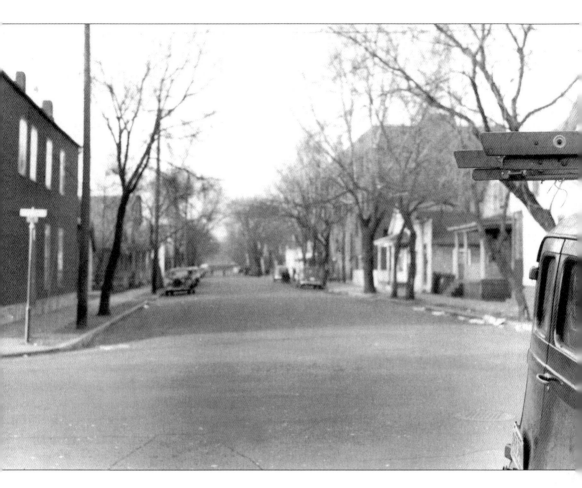

This scene shows State Street and Robertson looking down towards Indiana Street and the Neighborhood House to the right. (Courtesy of the Jewish Historical Society of the Upper Midwest.)

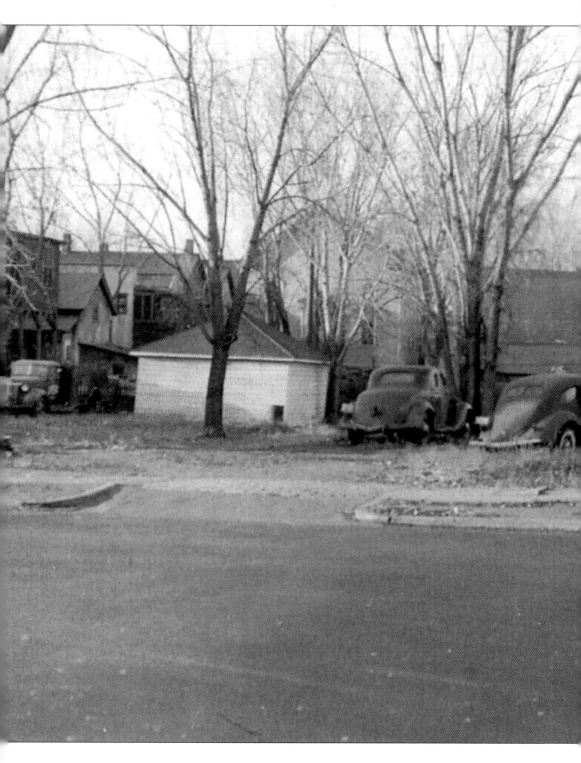

Not all of the lots on State Street were occupied with homes, apartment buildings, or businesses. Shown here is an empty lot with cars and a variety of junk parked upon it. A driveway can be seen in the foreground.

(Courtesy of the Jewish Historical Society of the Upper Midwest.)

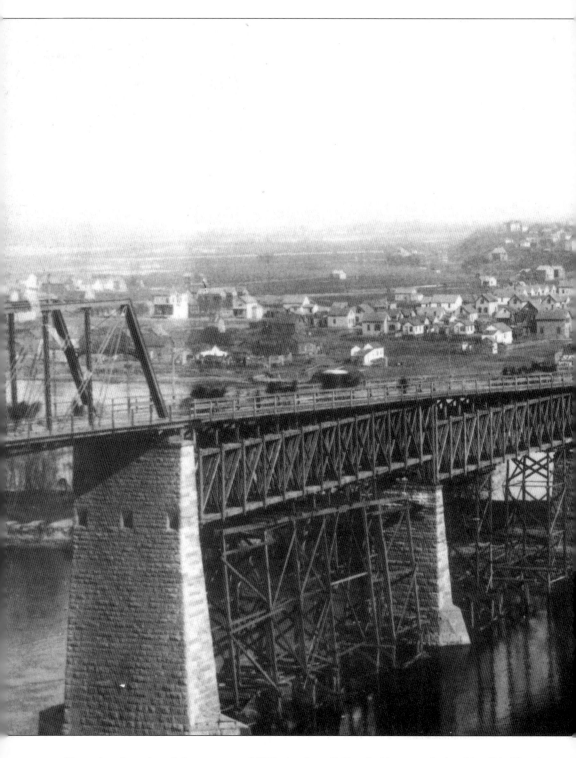

Shown here is a view of the reconstructed Wabasha State Bridge, looking towards the West Side Flats in 1890. Horses and wagons of the many peddlers that lived on the "Flats" can be seen crossing the bridge.

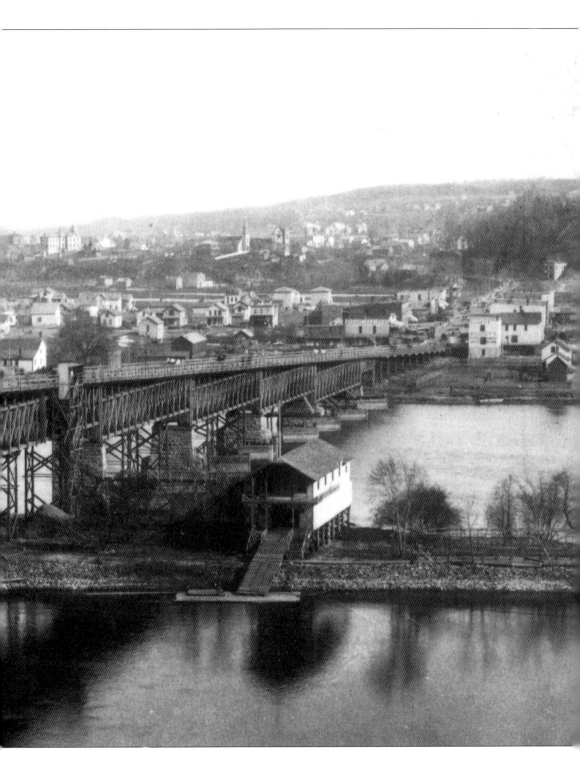

(Courtesy of the Minnesota Historical Society, photo by T.W. Ingersoll.)

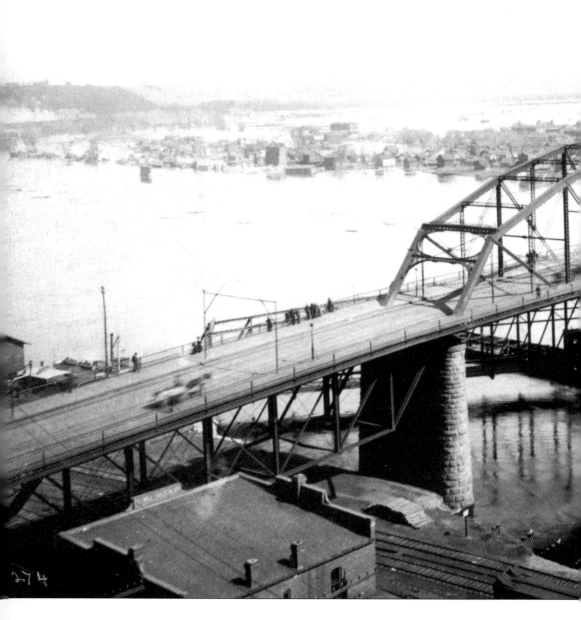

The new Robert Street Bridge, constructed in 1886, is shown here in 1896. It was built to supplement the heavy traffic across the Wabasha Street Bridge from downtown St. Paul in to the West Side Flats. Peddlers'

horses and wagons could be seen crossing the bridge on a daily basis. (Courtesy of the Minnesota Historical Society.)

This was a typical grocery store on the West Side Flats of St. Paul. Every block and every street has a store like this one. Many of the refugees started off as peddlers and then opened up grocery stores, living above the shops with their families. Generally, these were marginal businesses, but they kept their families fed and they were able to sell the surplus. (Courtesy of the Minnesota Historical Society.)

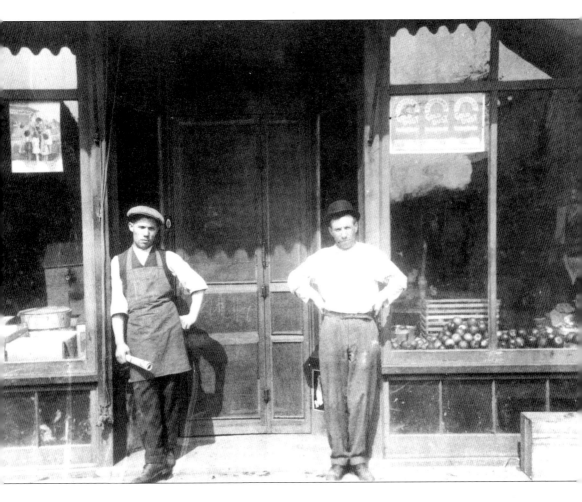

Shown here is William Rutzick (right) standing in front of his newly purchased grocery store at 146 State Street, in 1914. To the left is his cousin, Joseph Rossov, whom he bought out in 1918. Rutzick eventually bought another grocery store located in the downtown area at 553 Sibley. (Courtesy of Mark C. Rutzick.)

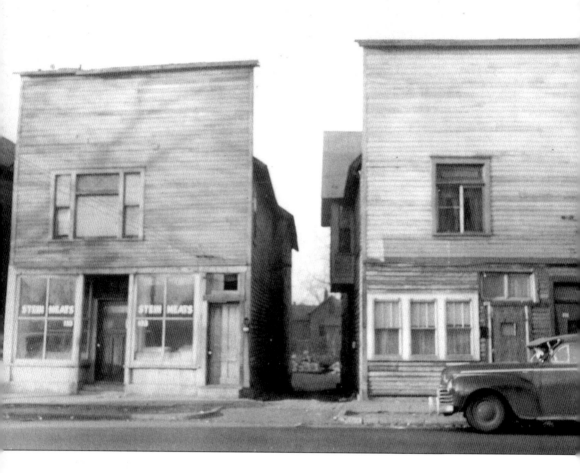

Shown here is Stein's Meat Market (left), one of the many small businesses on the West Side Flats. (Courtesy of the Jewish Historical Society of the Upper Midwest.)

This scene shows the "airport road" that began at State Street. Originally, it was named Perry Street and ran from Plymouth and Brooklyn Streets south of Bayfield Street. State Street was very long, carrying most of the traffic, much of which would turn left on St. Lawrence Street to reach the airport until the airport road was constructed. Eventually, St. Lawrence Street was bypassed by this road, which ran between Goldberg's Junk Yard to the left and Gottlieb's Junk Yard to the right. (Courtesy of the Jewish Historical Society of the Upper Midwest.)

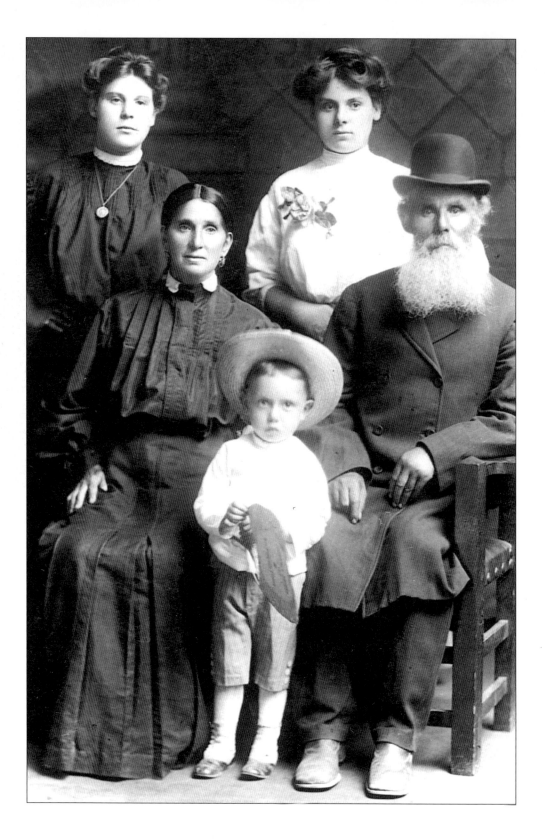

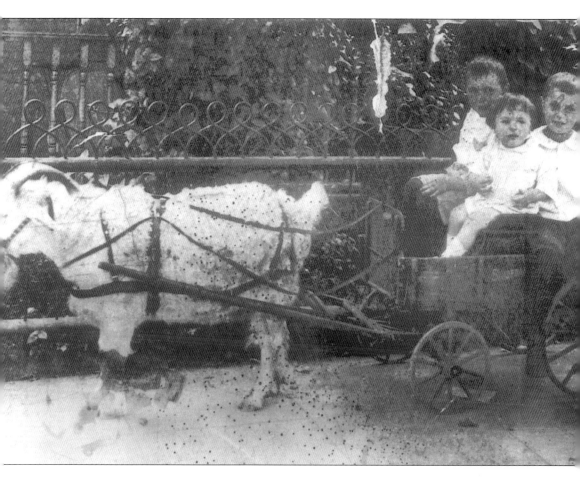

An itinerant free-lance photographer caught this picture of three of Jacob Goldstein's sons when they lived on the West Side Flats near the Neighborhood House, c. 1915. Shown here from left to right are Sam (age 6), Harold (age 1), and Allen (age 8). Jacob had bought the duplex at 206 East Indiana from an earlier Jewish refugee couple, Jacob and Etta Fendel. (Courtesy Harold Goldstein.)

OPPOSITE: *In the 1910 Polk St. Paul City Directory, Isaac Frank (sitting at right) was listed as one of several hundred Russian refugees living on the West Side Flats who worked as a peddler. His family says that he peddled fish for a while. In 1918, he was required as a non-citizen to file "Alien Registration and Declaration of Holdings" forms, which showed he had no occupation. Here he is shown with three of his children—daughters Mamie and Dora (standing left to right), and son Maurice (front)—and his wife, Toby (sitting at left). (Courtesy of Shari Taple Lowenthal, his great-great-grand-daughter.)*

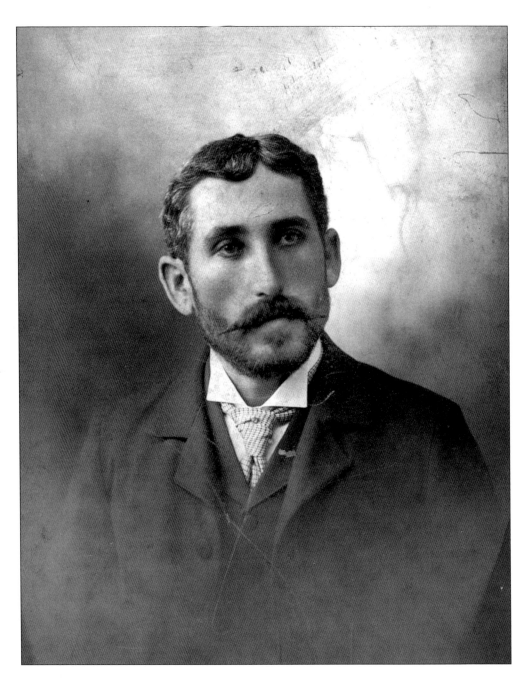

Some of the early refugees literally worked their way from "the ground up" to be highly successful businessmen. Shown here in this 1900 photo is Abe Goldberg. Born in 1870, in the Ukraine, he was forcefully inducted into the Russian army, serving for four years. After the Czar was murdered in 1881, he was permitted to leave Russia. Goldberg first settled in Boston and worked as a tailor, and then moved to Owatonna, Minnesota, working as a scrap iron peddler. He carried his wares on his back until he acquired a horse and wagon. In 1904, he moved to St. Paul to settle at 239 East Fairfield, organizing St. Paul Scrap and Metal. He and his wife, Sarah, had six children. (Courtesy of Firma Gordon Bender, his granddaughter.)

IV.

Peddlers and Other Occupations

For most of the refugees, the voyage to America and to St. Paul, Minnesota was a thirty day leap from a ghetto medieval age into a nineteenth century mercantile jungle. After the shock of traveling steerage across the Atlantic Ocean had worn off, they faced the challenges of the daily struggle to feed themselves and their families. (38)

The immigration of the Jewish refugees from Eastern Europe into St. Paul had begun with a shock. Reality had set in. (39) The first Jews to settle on the West Side Flats had been peddlers. But more were coming. Every day, the railroads were depositing entire families. Once the newcomers had settled in, the entire character of the Jewish community in St. Paul was irrevocably changed.

They discovered that even the poorest of the poor in the community had something to sell at one time or another. (40) They became junk peddlers, using a horse and wagon for mobility, buying these items cheap and selling them to junk dealers at a small profit. In this way they could cling to a niche not quite at the bottom of the social ladder. (41) The junk peddlers had become entrepreneurs and were no longer among the poorest of the poor.

Not all peddlers were junk peddlers, however. Some sold fish, and others sold fruits and vegetables. Some sold fresh eggs and poultry. What they had in common was that they bought in bulk cheap and sold for a small profit.

These were intrepid individualists, for they were in a world where dirty bricks and dirty tricks were a daily happening. Most of them bit their tongues and went about their daily rounds. They were tormented by the "street kids," who called them "Christ Killer," or "Kike" and "Sheeny". (42) But when the day was over, they and their horses and wagons retreated to their modest homes and their synagogues. (43)

They paid in cash from a pouch nestled inside of their shirts and were willing to buy and sell anything. They bought rags, paper, mattresses, bottles, burlap, furniture, old clothes, stoves, and everything else someone did not want anymore. They went to the city market and bought fresh fish, fruit, vegetables, eggs and poultry from the farmers. Later, some opened grocery stores, or meat and fish markets.

They attended their daily prayers wherever there was "Minyan". (Note: a "Minyan" consists of ten adult male Jews who could form their own prayer group according to biblical rules.) (44) After prayer, they became a social group discussing business and setting their prices for the daily business.

Not everyone became a peddler, however. The earliest settlers had been peddlers, but those that followed were able to follow other pursuits. Many became tailors, butchers, bakers, feed dealers, carpenters, harness makers, capmakers, cigar makers, coopers, blacksmiths, egg candlers, barbers, grocers, and confectioners. By 1910, at the peak of Jewish immigration, the streets on the West Side Flats were lined with all kinds of occupations. (45)

Along State Street, one could find many stores, meat markets, bakeries, feed dealers, junk and scrap iron shops, capmakers, shoemakers, furriers, candy stores, harness makers, and so on. Those without particular skills became common laborers.

The same was true along Fairfield, Indiana, Kentucky, Robertson, Texas, Eva, Chicago, Eaton and all the other streets along where they settled. Still, most of the activity was along State Street. (46)

There were Isaac Cohen's, Mary Goldstein's, Dena Shapiro's, Sarah Tallenberg's, Morris Baker's and Abraham Wegofsky's grocery stores. Fisel Fishman and Louis Rose had meat markets. There were Harry Brussel and Harry Edelson, the bakers; Louis, Jacob and Max Goldberg, Benjamin Gottlieb, Jacob Resnick, Louis and Samuel Misel, the junk dealers; and

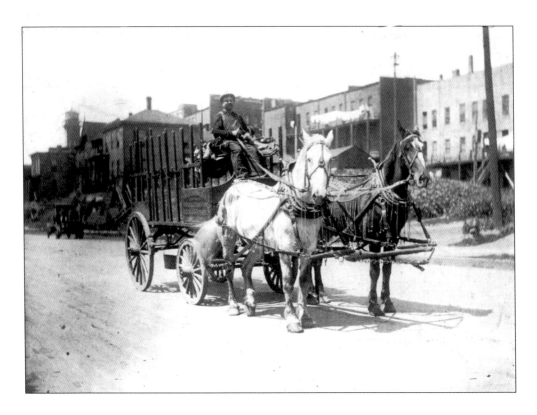

The first wave of early refugees all became peddlers after they settled into the West Side Flats. It was not uncommon to see these hardy entrepreneurs and their horses and wagons crossing back and forth over the Robert Street Bridge to peddle their wares. (Courtesy of the Jewish Historical Society of the Upper Midwest.)

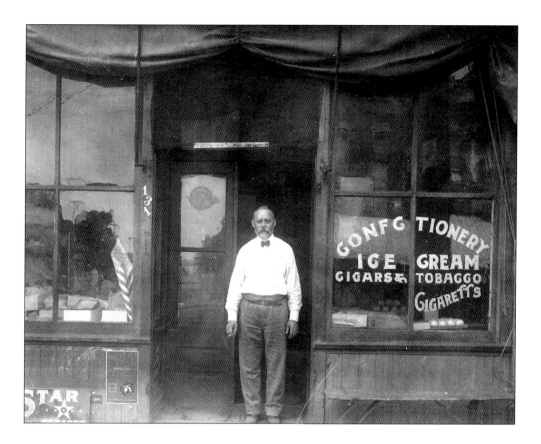

Charles and Marcus Silverman established their candy store at 131 State Street on the West Side Flats. They represented the refugees that had gone into businesses other than peddling after their arrival in St. Paul in 1882. (Courtesy of the Jewish Historical Society of the Upper Midwest.)

Samuel Arovits, Jacob Berman, Abraham Blumberg, Bernard Braverman, Abraham Cooperman, Simon Fink, Benjamin Forman, Abraham Kanter, Abraham Katz, Isador Stein and Arthur Silver, the tailors. There was Victor Katz, the egg candler. There were many, many more along State Street in various occupations.

Along Fairfield Avenue there were Abraham Goffstein, Abraham and Philip Geller, and Julius Rosenthal dealing in dry goods. There were Abraham Cooper and Nathan Herman, the blacksmiths; Morris Rutzick's feed store; Aaron Stacker's candy store; Henry Cumonow's, Samuel Roisner's and Max Shilkrout's grocery stores; Peter Milkes's meat market; Louis Rosenblum's fish market; and Morris Rosenblum's bakery. There was Louis Kaminetsky, the saddle maker. (48)

Along Kentucky Street was Jacob Cheinek, the egg candler and grocer; Philip Pleason and Harry Blumstein, the harness makers; Meyer Barnstein, Morris Cohen, Joseph Forman, Abraham Katz, Max Kolinske and Max Sadofsky, the tailors; and Joseph Effress and Max Resnick, the scrap dealers. (49)

Along Indiana Avenue were Benjamin Kohler's and Henry Goldberg's meat markets and Mrs. Kathryn Millstein's and Mrs. Pauline Zeroff's grocery stores. There were Isaac Goldenberg and David Brooks, the bakers; Max Copilovich and Max Goldberg, the scrap

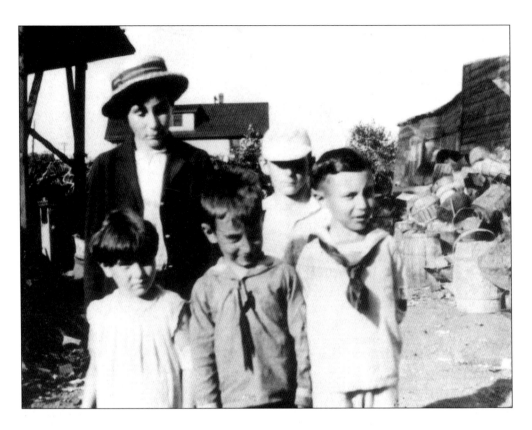

George Chase made a visit to St. Paul at the beginning of the 20th century, fell in love with and married Lottie Frank, daughter of Isaac Frank, patriarch of the Frank family that first lived at 308 Texas Avenue. The newlyweds lived on the Flats for a while, and then moved to Vermont until 1916, when they returned to St. Paul and bought out one of the earliest refugee businesses, Farsht's Junk Yard at 98 Eaton Street. Shown here are Chase's children and some of their friends playing amongst the scrap iron. From left to right they are (front row) Natalie Chase, Jack Chase, Oliver Tankenoff, and (back row) Samuel and Sidney Chase. (Courtesy of Shari Taple Lowenthal, his great-niece.)

iron dealers; Harry Goldberg, the butcher; Jacob Bard, Max Goldberg, Harry Grossman and Charles Schwartz, the tailors; and Hyman Butwinnick, the furniture dealer. There was David Weinstein's clothing operation. (50)

Along Robertson Street was Samuel Gilman, the bottler; Aron Goldberg's grocery store; Fishel Fishman's and Henry and Jacob Goldberg's meat markets; and Harry Braverman, Max Jaffee and Harry Kaufman, the tailors. (51)

Along Eaton Avenue, there was Benjamin Birnbaum's billiards; Morris Birnberg's wholesale tobacco; Maurice Blehart, Herman Keller and Joseph Makiesky, the tailors; Samuel Wellman's candy store; Reuben Birnberg's grocery store; and Joseph Farsht's junk and scrap operation. There was Benjamin Bromberg, the carpenter. (52)

Along Texas Avenue, there were Harry Cohen and Israel Halpern, the carpenters; Samuel Frank, Roy and Reuben Gilman, the tailors; and Hyman Rasnick, the blacksmith. (53)

Along Eva Street there was Nathan Friedman, the cap maker, as well as Charles Rosen's fish market and Anna Rosen's candy store. (54)

On Chicago, there was Benjamin Goldberg's candy store, and Morris Fox, the hatmaker. (55)

On South Robert there was Louis Cohen's grocery store along side Marcus Cohen's scrap iron dealership, as well as Louis Goldman, Hyman Rosenberg and Joseph Goldberg, the tailors. (56)

On Fillmore there was Morris Bartnosky the butcher and Samuel Eblinsky, the tailor. (57)

On Water Street, by the Mississippi River banks, was Samuel Greenberg, the scrap dealer, and Jacob Berkes, the printer. (58)

On St. Lawrence Street, there was Isador Goldsmith, the tailor. (59)

On South Wabasha Street there was Solomon Cohen's grocery store. (60)

On Plato there was David Kaplan, the printer. (61)

On Minnetonka, there was Herman Glickman's furniture store, and David and Jacob Pleason, the harness makers. (62)

Everybody worked. The wives, daughters and sons all pitched in. The wives and daughters worked as seamstresses and milliners. They also worked as machine operators in hat factories and clerked for the various downtown department stores such as Mannheimer's, Bannon's, and the Golden Rule. The sons helped as cigar makers and strippers, machine operators, clerks, pressers and cutters, mailers, teamsters, packers and newspaper boys. (63)

It was a bustling, vibrant and colorful community in 1910, the year that the immigration to the West Side Flats appeared to have peaked.

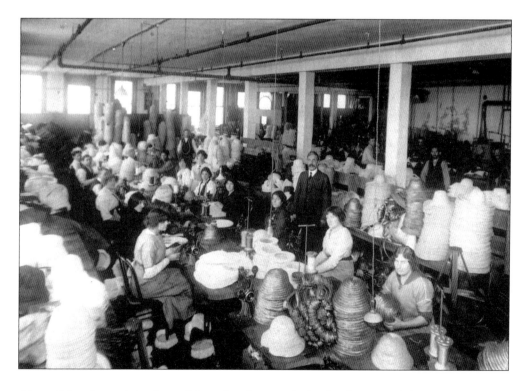

Many of the wives and daughters of the early refugees worked in hat factories to help their husbands and fathers make a living. (Courtesy of the Jewish Historical Society of the Upper Midwest.)

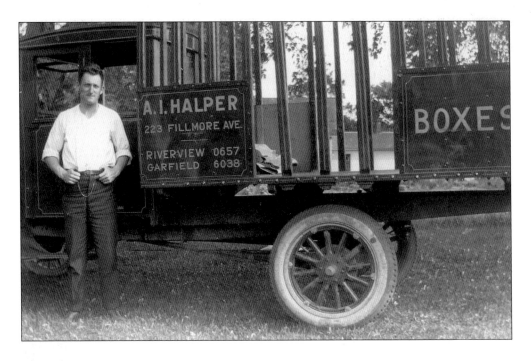

Another of the early enterprises on the West Side Flats were box factories. A.I. Halper is shown here beside his truck. (Courtesy of the Jewish Historical Society of the Upper Midwest.)

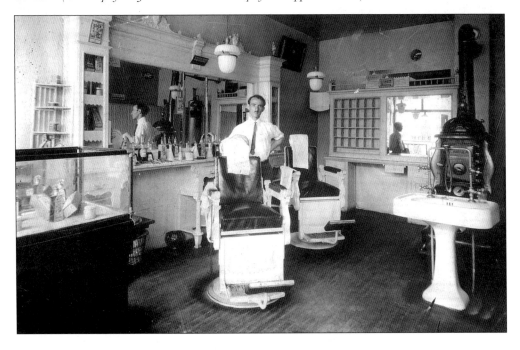

Not all of the early Jewish refugees had their businesses on State Street. Pictured here is Simon Londer at his Fairfield Street barber shop, at the front of the building in which he and his family lived. (Courtesy of Mrs. Frances Gardner, his daughter.)

Shown here is Abe Goldberg's daughter Minnie, who was born in Owatonna, Minnesota, in her wedding picture with Samuel A. Gordon of Minneapolis. She was one of the first girls to attend Hebrew School in St. Paul at Talmud Torah, which her father helped organize along with Rabbi Simon, and of which he was the first president. Mr. Gordon took over the St. Paul Scrap Iron and Metal Company from his father-in-law, Abe Goldberg. (Courtesy of Frima Gordon Bender, her daughter.)

Mrs. Sophie (Jacob) Wirth succeeded Mrs. Julius (Hanna Leopold) Austrian as president of the Hebrew Ladies Benevolent Society of Mount Zion Synagogue when Mrs. Austrian retired. Mrs. Wirth, together with Rabbi Emmanuel Hess and later Rabbi Isaac Rypins were the driving forces behind the establishment of the Neighborhood House on the West Side Flats. She started by hosting sewing classes in her home for the wives and daughters of the first Russian and Eastern European refugees. It later expanded into an "Industrial School" and finally became the Neighborhood House. (Courtesy of Minnesota Historical Society.)

V.

The Neighborhood House

In 1893, an economic panic brought unemployment, poverty and fear to the residents of the West Side Flats. The German-Jewish ladies of the Hebrew Ladies Benevolent Society determined that something had to be done to help the new Jewish refugees. Their children had to learn skills to sustain them and learn American ways. They started sewing classes in April of 1893 to begin the process. (65)

The refugees from Russia, Lithuania and Poland continued to flow into the West Side Flats. In April of 1895 the gentle ladies of the Hebrew Ladies Benevolent Society contributed $100 to the opening of an "Industrial School" on the West Side Flats and rented rooms on Fairfield. They were "hopeful that this most worthy charity would provide a blessing to the children of the poor." (66) No fewer than 73 young Jewish girls enrolled, eager to learn home and industrial arts, study English, and participate in an "Americanization" program. (67)

Winter classes were soon added. In July of 1897, the school was offering lessons in sewing, dressmaking, darning and mending, and making new clothes from old. In the fall, a boys' manual training department was opened. (68)

By 1897, there were both boys and girls in the Industrial School (69) as more and more immigrants were settling on the West Side Flats. The work of the school began to expand and classes were now extended to adults as well. (70) The modest quarters on Fairfield now served as a real Neighborhood House. In 1897, a converted four-flat at 153 Robertson was acquired, which offered larger quarters. (71)

By 1900, the Neighborhood House was an established social entity in St. Paul. As Bill Hoffman in *West Side Story, II* so aptly states: "Whatever the West Side was, it was Neighborhood House." (72) It was served by the gentle ladies of the Mount Zion's Hebrew Ladies Benevolent Society under the direction of Mrs. Sophie Wirth, who had succeeded Mrs. Julius Austrian as its leader, and Rabbi Emmanuel Hess until 1899, and then Rabbi Isaac Rypins. (73) Rabbi Rypins taught English classes at night. (74) Even after the majority of the Jewish refugees had moved off of the West Side Flats, the rabbis and German-Jewish

Rabbi Emanuel Hess of Mount Zion Synagogue, together with Mrs. Jacob Wirth of the Hebrew Ladies Benevolent Society, helped to establish the Neighborhood House on the West Side Flats. They organized an "Industrial School" to teach young Jewish boys and girls in home and industrial arts, and later created classes in "Americanization" to help adults gain their citizenship. (Courtesy of Mount Zion Synagogue.)

members of the Mount Zion Synagogue continued to serve on the Board of the Neighborhood House.

By 1903, the Neighborhood House reorganized into a wider and non-sectarian basis, turning itself from a purely Jewish social effort into a West Side community center. Also by 1903, it was in larger quarters at 151–157 Robertson at Indiana Street, which it had rented from Simon Giss. (75) A three-year lease of the premises was originally made, and the rent was $450 for the first year and $500 for the second and third year. The landlord was to make all of the repairs, in the original lease, but he had a change of heart, and the rent was reduced to $400 a year, with the Neighborhood House making all of the repairs. (76)

In 1905, the first night school was opened with Macalester College students acting as volunteer teachers. (77) In 1907, a paid teacher opened additional English and "Citizenship" classes. It was now a place where Jew and Gentile could mix and it provided several generations of youth a place to go. (78)

It became necessary to have someone supervise the daily activities within the confines of the Neighborhood House. A "Head Resident" was hired for $50 a month to live on the premises. (79)

The first of the Head Residents was a Mrs. Pentland, and a year later, a Mrs. Clara Kellogg. (80) From time to time college and other hungry students lived and worked in the building. (81)

The various clubs that occupied and used the building helped raise money to maintain the building and its "gymnasium fund." (82) There were picnics and plays and various forms of "quiet" games to round out the evenings. There were baseball teams and other

Rabbi Isaac Rypins, who succeeded Rabbi Emanuel Hess at Mount Zion synagogue, worked hard to support the Neighborhood House on the West Side Flats. He taught English classes at night and established the tradition of Mount Zion Rabbis serving on the Neighborhood House Board of directors. (Courtesy of Mount Zion Synagogue.)

forms of recreation. (83)

After 1910, the character of the West Side Flats began to change as some of the refugees and their descendants began to move to higher ground in the West Side Hills, to the newer "uptown area" around Thirteenth and Fourteenth Streets, or up to the "Hill District" around Selby and Dale. Hispanics, drawn by the jobs available in Minnesota's sugar beet fields during World War I, began to buy the homes of the original refugees. This changed the character of the Neighborhood House as well.

In June of 1918, Miss Constance Currie became the long-time director of the Neighborhood House. The first thing she discovered was that almost every boy in the neighborhood had a complete set of keys to all the locks in the Neighborhood House. (84)

As the character of the neighborhood changed, so did the Neighborhood House. In 1903, it had become non-sectarian, and by the 1920s it became necessary to move off of the West Side Flats. In 1923, construction was begun for a new Neighborhood House at 179 E. Robie Street. It remains there today as the only surviving institution from the old West Side Flats.

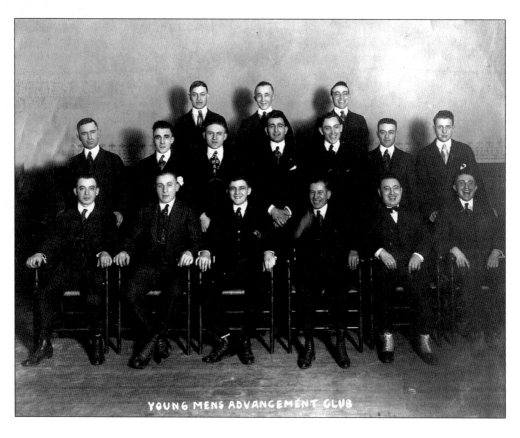

YOUNG MENS ADVANCEMENT CLUB

The Neighborhood House established many clubs to help young Jewish boys and men gain their self-esteem. One of these was the Young Mens Advancement Club, shown here. (Courtesy of the Jewish Historical Society of the Upper Midwest.)

The Neighborhood House at Indiana and Robertson had a branch of the St. Paul Public Library within its confines. This building, acquired in 1897, was a converted four-flat which served several generations at this location until 1923, when it was replaced by a larger facility at 179 East Robie in the "West Side Hills." (Courtesy of the Jewish Historical Society of the Upper Midwest.)

Some of the refugees were highly skilled workers. Shown here is Jacob Goldstein (left) with Sam Cohen, his brother-in-law, in the early 1900s. Jacob, a sheet metal worker back in Romania, married Sam's sister Clara Cohen and they had four sons. For many years they lived in a duplex in the shadow of the Neighborhood House at 206-208 East Indiana. (Courtesy of Bruce Goldstein, his grand-son.)

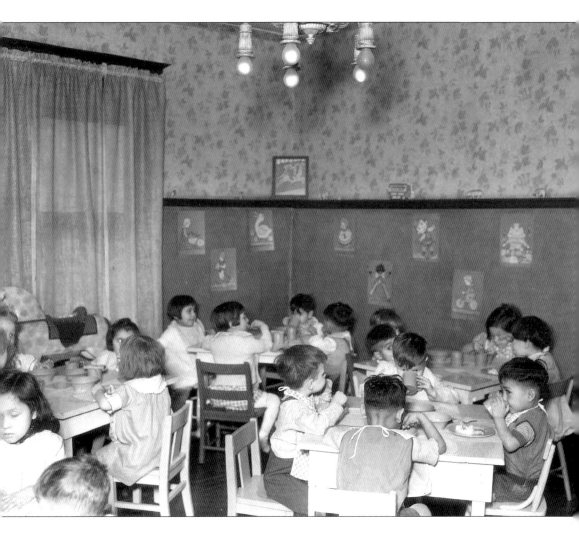

The Neighborhood House was a part of the WPA Nursery School Project, which provided nutritious lunches during the Great Depression. These children, who were preschoolers, could receive a free hot lunch every day. Shown here is a group of children eating lunch in January of 1936. (Courtesy of Minnesota Historical Society.)

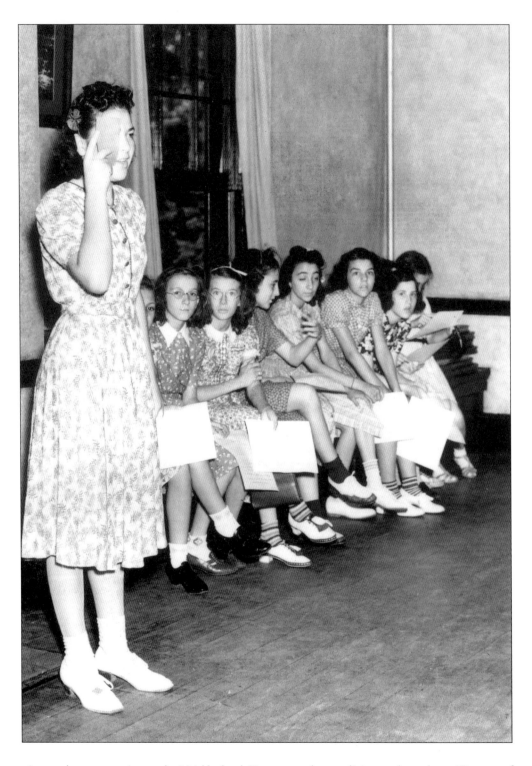

Among the many services at the Neighborhood House were the eye clinics, as shown here. (Courtesy of Minnesota Historical Society.)

Synagogues and Other Amenities

Life was very hard on the early West Side Flats. Most of the streets were never paved, very few sewers existed, and the Mississippi River flooded practically every year. Many of the modest frame houses had no grass, but they did have trees, which they yanked from the banks of the river. There were no public playgrounds for the children until the city built the Minnetonka playground in June of 1919.

Residents raised chickens in their back yards and kept their horses and other animals in sheds behind their houses. There was no central heating in most of the modest frame homes, where they used kerosene or coal for heating fuel in individual rooms. There was no plumbing or electricity, no basements (they had limestone cellars, if they had cellars at all), and no hot water for bathing. It was necessary to go to the Wilder Public Baths in the downtown area for the weekly showers for the boys and baths for the girls, unless they went to the steam baths next to the Mikvah (a place for ritual baths for women) on Fillmore. (85)

When telephone service did arrive, it served the whole area from Robert Street to the river. The service was located in a drug store on South Robert and Fillmore, and was only used in emergencies to call a doctor. (86)

There were some amenities, however. Their spiritual life was rich and there was the spirit of everybody pulling together. There was the Mikvah for ritual bathing, the synagogue for spiritual healing, and the Talmud Torah (Hebrew School) for the children's education.

When Jews settled in any community, the establishment of a synagogue, Talmud Torah and cemetery were of utmost importance. The cemetery could not be more than one or two hours away by horse and buggy.

In Jewish life, after the fall of the Second Temple in Jerusalem, the Jews of the Diaspora—the thousands that were scattered around the world—invented the Minyan and the synagogue. The Minyan allowed ten adult Jewish men to pray together without the benefit of a physical structure. The synagogue gave them a holy structure where they could

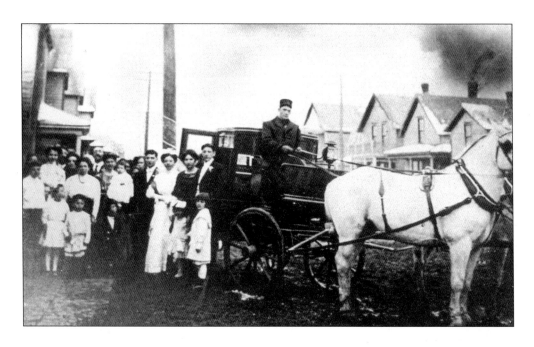

The wedding of Fanny Abromovich and Isadore Spiszman on April 17, 1910, is shown in front of 210 State Street. (Courtesy of the Jewish Historical Society of the Upper Midwest.)

place the Torah (the Holy Scriptures) without having to go to the now destroyed Temple in Jerusalem. The synagogue also gave them a community center from where they could organize Jewish life.

In the orthodox synagogue, men and women were separated. The men wore prayer shawls and sat on the main floor around the Bima (altar). The women were in the gallery in the balcony, which was usually swept in a horseshoe curve against the back walls.

During the High Holidays of Rosh Hashana and Yom Kippur, the women and their daughters followed the prayers as their husbands and sons sat down below. (87) The women wept openly, freed from the constraints that forced the men to keep their feelings deep inside the wellspring of their hearts. (88)

All of the early synagogues on the West Side Flats were Orthodox. The German Jews of Mt. Zion Temple, which was in the downtown area around Tenth and Minnesota Streets until 1903, had joined the Reform movement after 1878. The Sons of Jacob and the Sons of Moses served the balance of the orthodox community outside of the West Side Flats, and the Conservative movement did not arrive in St. Paul until after 1910.

For the early refugees on the West Side Flats, the synagogue provided a refuge from the daily travails of life. Two early synagogues of frame construction were Chevra Misinas Askinas, the "Texas Avenue Shul," built in 1889 at 284 Texas Avenue, and B'nai Zion, the "State Street Shul," built in 1901 at 150 State Street. The magnificent Agudah Achim was constructed of brick by the Russian Brotherhood on East Fillmore in 1902. The rest of the early synagogues were often of simple design and frame construction. (89)

The Chevra Misinas Askinas, the "Texas Avenue Shul," was the smallest of the congregations. Its original building, which was constructed in 1889, was replaced when a fire damaged the building and a new one was built in 1923. The Beth Hamedrash Hagodol,

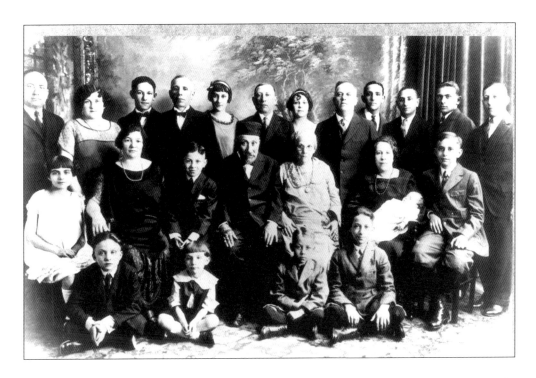

The Joseph Rutzick family is pictured here in 1924, from left to right, as follows: (front row) Alvin Rutzick, Sherman Rutzick, William Zeff, and Milton Zeff; (middle row) Doris Rutzick, Lena Rutzick, Henry Rutzick, Joseph Rutzick, and Leah Rutzick, the patriarchs, Jennie Zeff (holding baby Leon) and David Zeff; (back row) Louis Rutzick, Ida Rutzick, Max Rutzick, William Rutzick, Muriel Rutzick, Anne Rutzick, Abe Zeff, Harold Rutzick, Oscar Rutzick, and David Rutzick. The family had strong ties to the B'nai Zion Synagogue, as well as the Hebrew Free Loan Society and the Free Burial Society. (Courtesy of Mark C. Rutzick.)

which had moved from the downtown area, occupied a synagogue that was constructed at 165 State Street, across from the B'nai Zion. Some of the congregations such as Shaare Hesed va Emet, owned only their Sepher Torah (the Holy Scriptures), and rented space from the Congregation Beth Hamidrash Hagodol.

Each of these congregations had a colorful history, but for the most part, their records disappeared over the years. Sometimes a defeated secretary of the congregation threw away his notes, for spite, after he had joined another congregation.

For those congregations that could afford it, an iron fence connected to an iron gate sometimes surrounded the building.

On the inside of the synagogue was the "Bima," surrounded by long, hard, highly polished wooden pews facing East towards Jerusalem, with little brass plates to designate seating places. (90) Snuff boxes and heavy brass spittoons filled with clean white sand surrounded the pews.

The colored glass windows, when the synagogue could afford them, reached as high as the women's balcony. (91) On the "Bima" was the Holy Ark with the Torah hidden behind the curtains of the Ark, and above the curtains of the Ark standing in bold relief was usually either The Lion of Judah or the Star of David. (92)

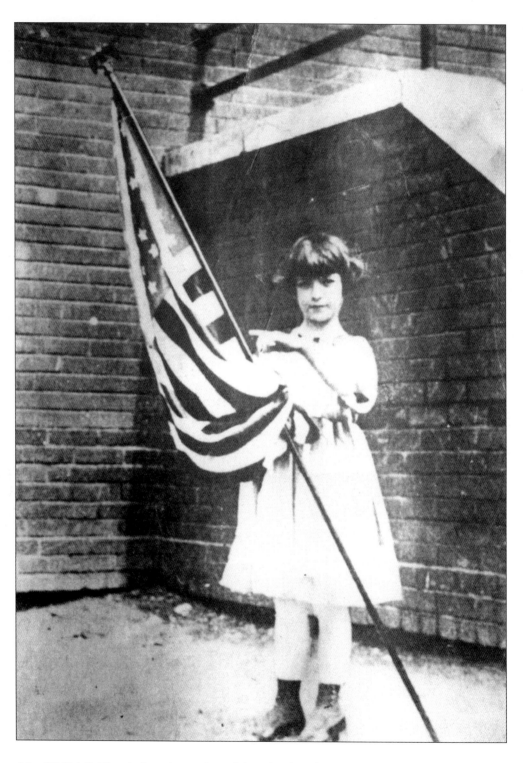

Mae (Kieffer) Goldberg is shown here in front of the Talmud Torah on July 4, 1915, holding the American flag. (Courtesy of the Jewish Historical Society of the Upper Midwest.)

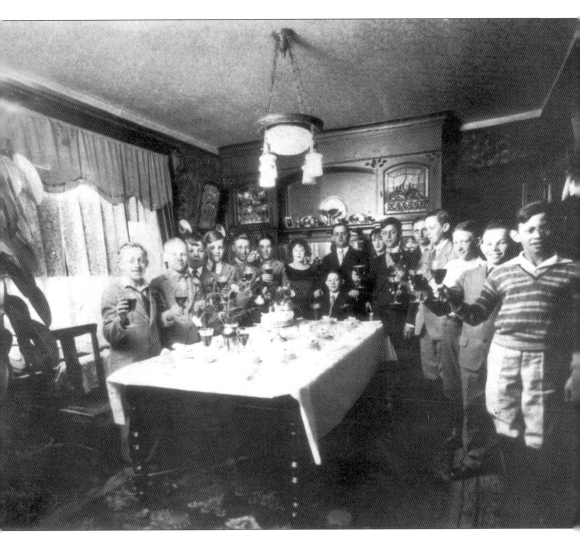

Ever since the 14th century, Jewish boys have celebrated their Bar Mitzvah upon reaching the age of 13. So it was that George Cohen, who was born in Russia in 1910, celebrated his Bar Mitzvah at his parents' modest home on the West Side Flats in 1923. His father, Morris, was a glazier who arrived on the West Side Flats when he was 44 years of age. (Courtesy Joan Jacobs, George Cohen's daughter.)

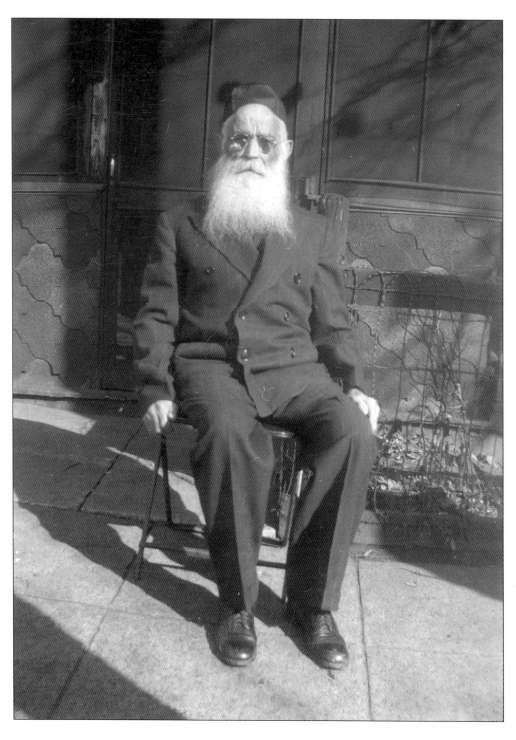

Another one of the early peddlers who arrived on the West Side Flats in 1900 was Samuel Kamenetzky. First he lived with his family at 164 East Fairfield, but later moved to 128 1/2 Eaton Street where he lived to the ripe old age of 92. (Courtesy of Scott Goldberg, his great-grandson.)

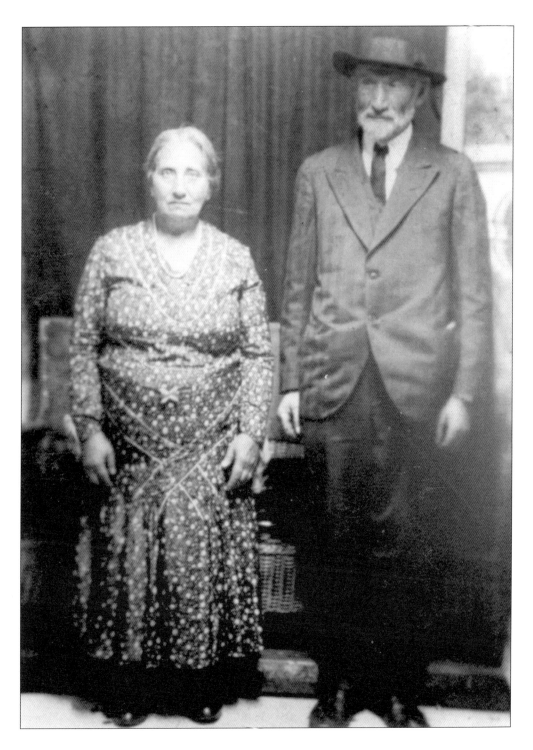

Another of the early residents of the West Side Flats listed as peddler in the 1910 City Directory was Samuel Katz, shown here with his wife, Ida. According to his family, he never had time to have a formal education, but was a "learned man." (Courtesy of his daughter, Janet Goldman.)

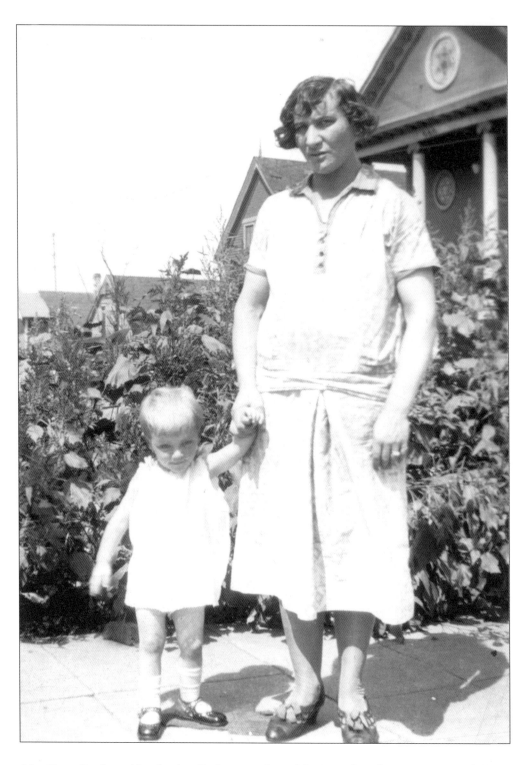

Mrs. Simon Londer and her daughter Ruth pose in front of the Sons of Israel Synagogue at Fairfield and Robertson Streets. (Courtesy Mrs. Frances Gardner, her daughter.)

The early refugee men went to the synagogue every day for prayer, and on the High Holidays (Rosh Hashana and Yom Kippur) they were joined by their families. The synagogue was often freshly painted for the holidays. (93) The concrete steps, if they could afford them, were swept clean, and the iron gate was oiled and opened wide. (94) The Ark and Torah were given freshly laundered covers, and flowers were placed on the "Bima." (95)

The synagogues were organized according to where one came from. The Lithuanian Jews had one synagogue, the Polish Jews had another, the Rumanians had yet another and the Russians often had more than one, depending upon which city or area they came from. (96)

On the West Side Flats, there was often one rabbi for more than one synagogue, as some of these congregations were quite poor. These congregations had organized an Orthodox Congregational Union and hired a Chief Rabbi. (97) A Chazen (cantor) was imported for the High Holidays at a price that the synagogue members would pay for over the entire year.

After 1910, the refugees and their descendants began to move to the West Side Hills, the "Uptown" area around 13th and 14th Streets, east of the Minnesota State Capitol building, or the Hill District near Dale and Selby. They continued to use the synagogues on the West Side Flats for their daily prayers, but they began to plan for new synagogues for their respective new homes. (98) Those that moved to the Hill District eventually built the

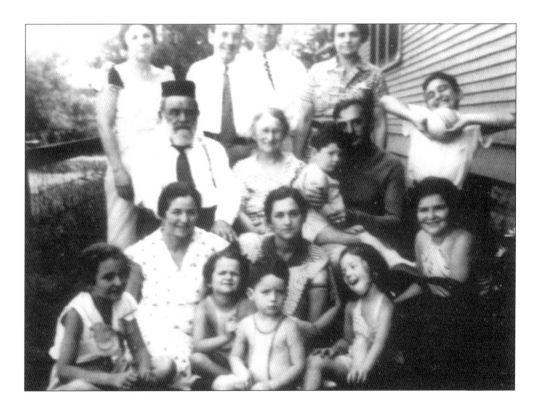

Rabbi Herman Simon is shown with his large family. Rabbi Simon was not only the Chief Rabbi for most of the orthodox synagogues, but he also supervised very closely the slaughter of meat and poultry. His most significant contribution was his leadership in establishing Talmud Torah and Sheltering House. (Courtesy of the Jewish Historical Society of the Upper Midwest.)

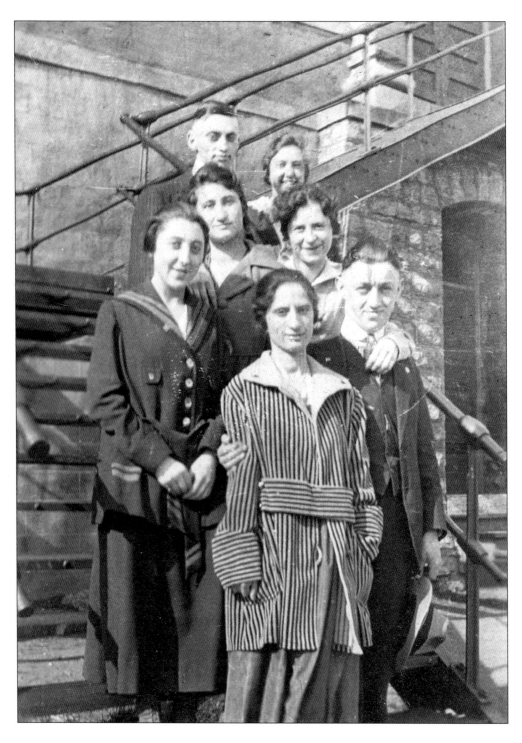

Posed in front of the Talmud Torah building are Lillian Frishberg, Palen and Jake Milchen, Libby Tenenbaum Singer, Ann Smith Borken, Jacob Weiss, and Nellie Kaminetzy Weiss. (Courtesy of the Scott Goldberg, Jacob Weiss's grandson.)

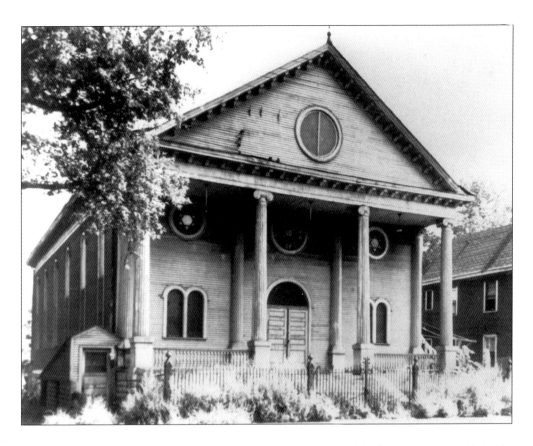

B'nai Zion, or Sons of Zion Synagogue at 150 State Street was one of the first synagogues established by the Russian refugees on the West Side Flats. Their early services, before this building was constructed in 1901, had been held in a feed store and a tent on vacant lot. (Courtesy of the Jewish Historical Society of the Upper Midwest.)

Temple of Aaron at Ashland and Grotto Streets. Those that moved to the Uptown area built the Sons of Moses at Thirteenth and Canada Streets, and those that moved to the West Side Hills in the 1920s bought the Clinton Avenue Methodist Church and converted it to the Beth David Synagogue.

The first formal Jewish education was provided at Mr. Bromberg's Cheder (Hebrew School) on State Street at Texas Avenue, before the Talmud Torah was built. Before the Talmud Torah was completed, weddings and other celebrations were held in the Royal Arcanium Hall in downtown St. Paul. This location across the Wabasha Street Bridge later became the site of the Lowry Medical Arts Building. (99)

A Talmud Torah was finally built in 1911 at 295 Kentucky Street. (100) On the main floor was the school, handling as many as three hundred children at one time. On the second floor was the Shelter House, which housed transients who were passing through the community on their way to different parts of the country.

The Shelter House provided food and lodging. It also housed many who came through on various missions, such as collecting funds for the establishment of the State of Israel, funds for the Yeshiva (schools that trained rabbis), or other good works. It had a kitchen

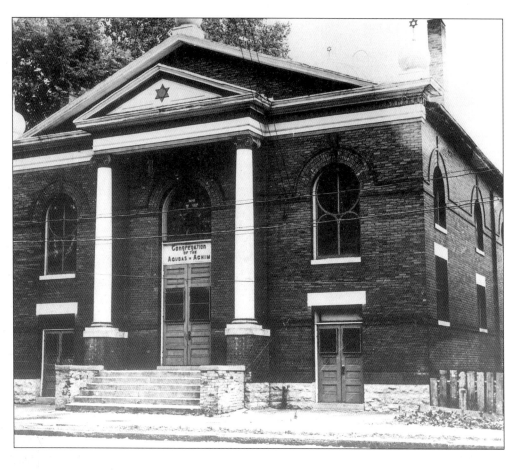

The Agudah Achim synagogue was constructed by the Russian Brotherhood at 200 East Fairfield. Its cornerstone shows the date of 1902. Its members were mostly refugees from Odessa and Kishnev. They first incorporated in 1886, and had services at 282 Texas Avenue before this building was built. Their first rabbi was Rabbi Herman Meckler, who was succeeded by longtime Rabbi Herman Simon. This synagogue held its last services in 1962. (Courtesy of the Jewish Historical Society of the Upper Midwest.)

and a maintenance staff, and provided kosher surroundings for those that wanted to maintain an association with other Orthodox Jews. (101)

Public school education was provided by the Lafayette School, originally called the River School, behind the B'nai Zion synagogue. Built in 1876, it was a twelve-room structure, two of the rooms having been added after the arrival of the first refugees in the 1880s. There was also the Edison School, originally called the Humboldt School, located on South Robert and Colorado, close to the West Side Hills, which was used as a "continuation school" for the children of the refugees. In 1911, the St. Paul school system created the "continuation school" for children under the age of 16 who had to work but wanted to earn the required credits to graduate high school. It had been built in 1879, with additions in 1884 and 1887 to accommodate the flood of refugee children. Then a new Humboldt School was built in 1888, and the original building was demolished. After becoming the Edison School, it served the community until 1927.

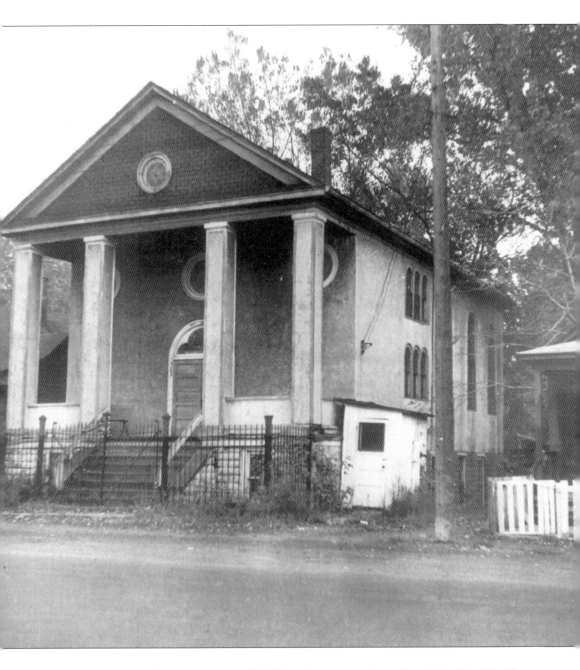

The Chevra Misinas Askinas Synagogue at 284 Texas Avenue was the smallest of the West Side Flat synagogues. It was established in 1889 by Lithuanian Jews, but the original building was destroyed by fire and the new one, shown here, was built in 1923. (Courtesy of the Jewish Historical Society of the Upper Midwest.)

The only high school on the West Side, Humboldt High School, which was constructed in 1888, was located in the West Side Hills about two miles from the Flats. The original building was used as a high school until 1911, when a new building was constructed.

For both students of the Edison School and the prospective high school graduates, it was a long walk each day to and from the school, and carrying their books was a burden.

There was no junior high school until portions of the Roosevelt School, also in the West Side Hills, were converted to a junior high.

The cemeteries were all located on the east side of St. Paul until the Temple of Aaron built their cemetery in the north suburbs at Dale and Larpenteur Streets. Even the so-called West Side Hebrew Cemetery was located on the near East Side on Barclay and East Maryland Streets.

Each of them had a burial society that managed the burials of the community, which were held in the decedent's home before the arrival of funeral homes. (102)

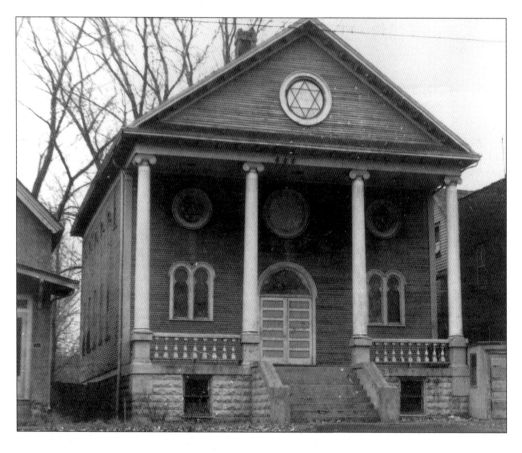

Sons of Israel Synagogue located at Fairfield and Robertson Streets was incorporated in 1907 by Lithuanian Jews and its building constructed in 1908. Together with a number of other small Orthodox synagogues it organized an Orthodox Congregational Union and hired a chief rabbi. The first was Chief Rabbi Abraham E. Alperstein. He was succeeded by Rabbi Herman Simon in 1888, who became a longtime fixture of the West Side Flats. (Courtesy of the Jewish Historical Society of the Upper Midwest.)

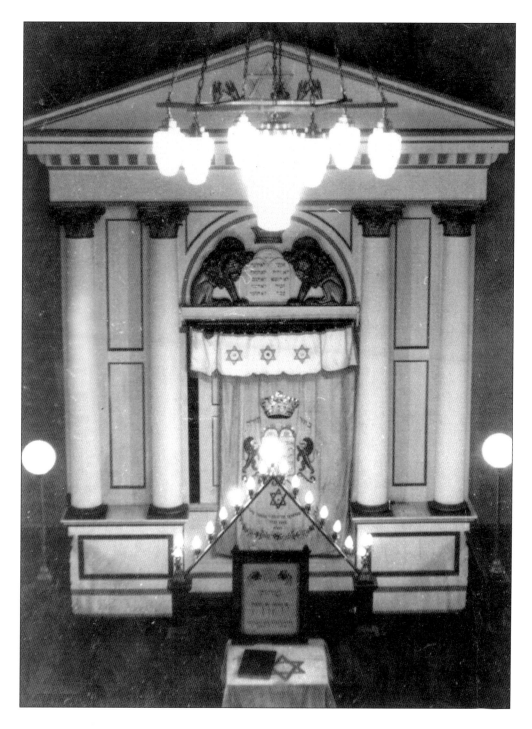

The "Bima" (altar) of the Sons of Israel Synagogue is shown here. (Courtesy of the Jewish Historical Society of the Upper Midwest.)

A good Jewish education for their children was the dream of every family on the West Side Flats, most of whom never had the opportunity or the time, either here or in the "old country." In 1911, the Talmud Torah Hebrew School was created. One of the most beloved and distinguished "cheder" teachers was Rabbi Israel Taple, shown here with his wife, Yetta. (Courtesy of his great grand-daughter, Shari Taple Lowenthal.)

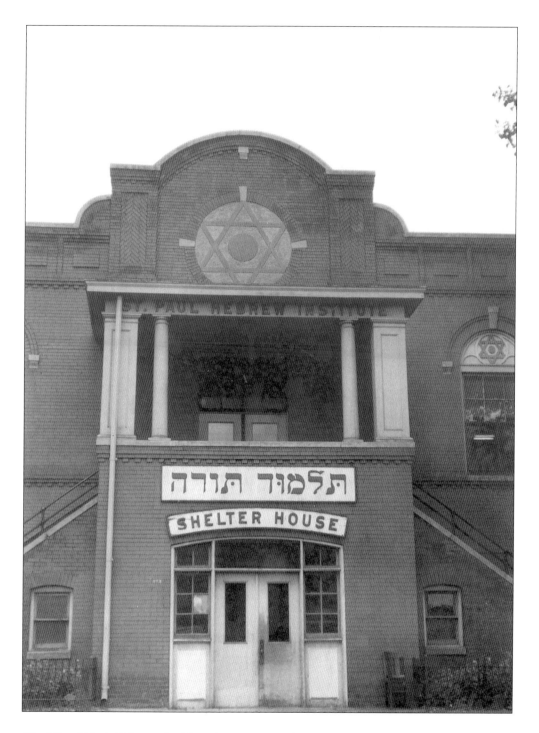

The Talmud Torah Hebrew School located at 295 Kentucky Street combined a school for teaching Hebrew with a shelter for indigents and transients. It was constructed in 1911, serving the Jewish community of the West Side Flats for many years until it, too, succumbed to the wrecking ball of the 1960s. (Courtesy of Mount Zion Synagogue.)

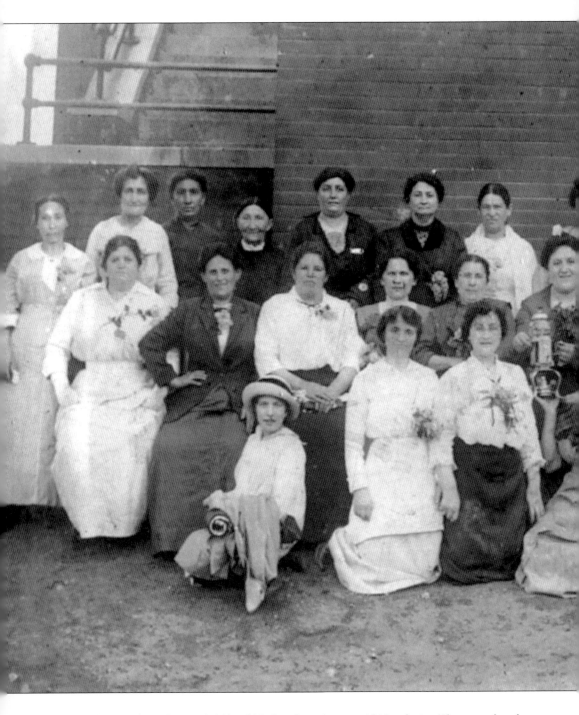

The Ladies Auxiliary of St. Paul's Talmud Torah is shown here at a 1915 gathering. These were the volunteers

that helped raise funds to support the Hebrew School and the Shelter House located on the second floor. (Courtesy of the Jewish Historical Society of the Upper Midwest.)

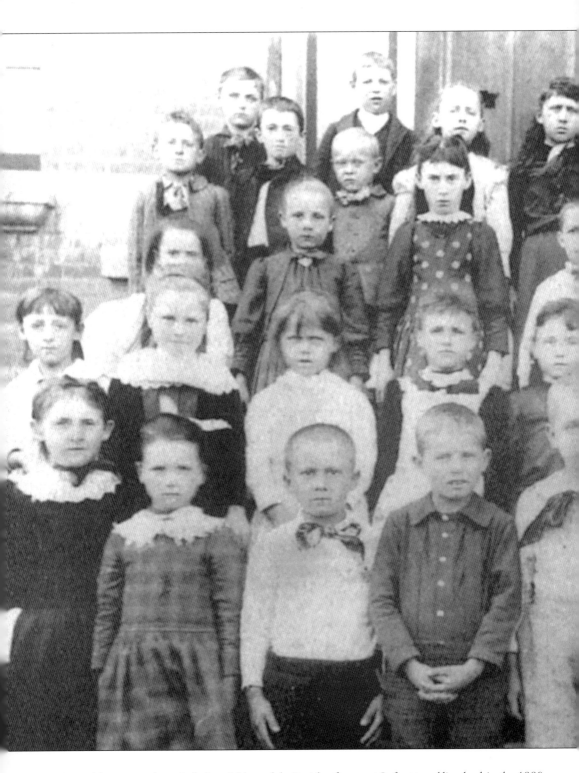

Pictured here are students, including children of the Jewish refugees, at Lafayette public school in the 1889-1890 school year. The original building was built in 1876. (Courtesy of the Jewish Historical Society of

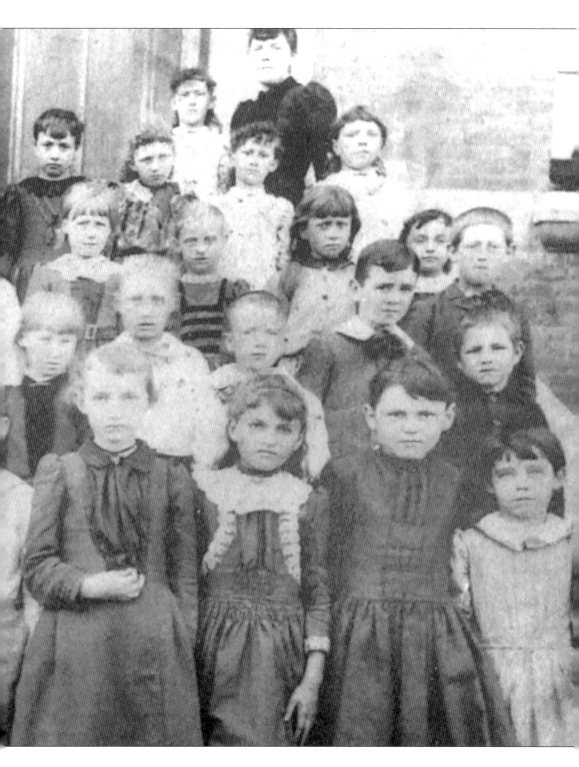

the Upper Midwest.)

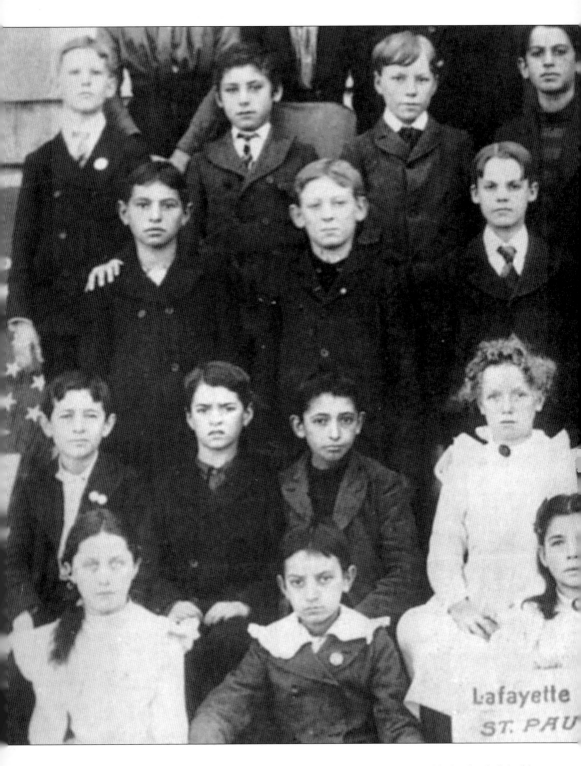

Pictured here in their new school are students of the public Lafayette School. The old school, which had been built in 1876, was finally replaced in the 1920s after Jewish parents of the students met at the Talmud

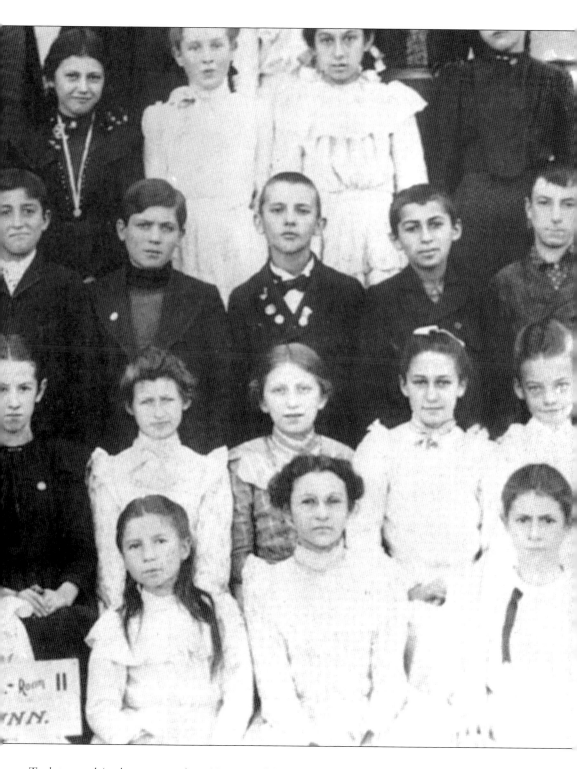

Torah to complain about overcrowding. (Courtesy of the Jewish Historical Society of the Upper Midwest.)

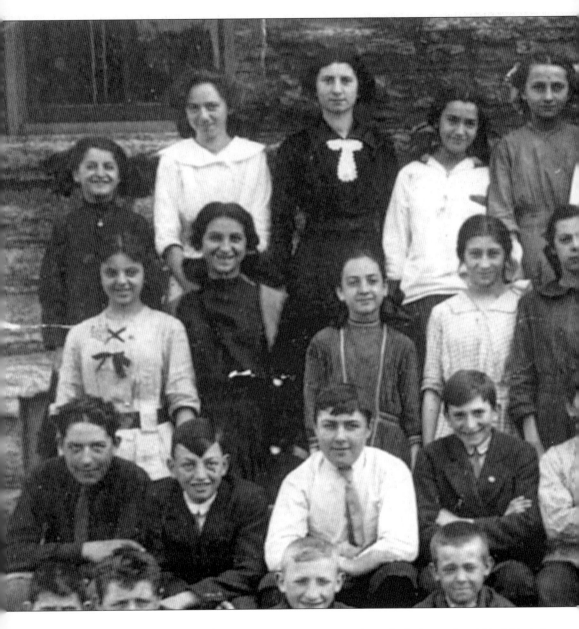

The Edison School was created for those children under the age of 16 who had to work, which did include most of the Jewish refugee children. Located at South Robert and Colorado Streets in the West Side Hills,

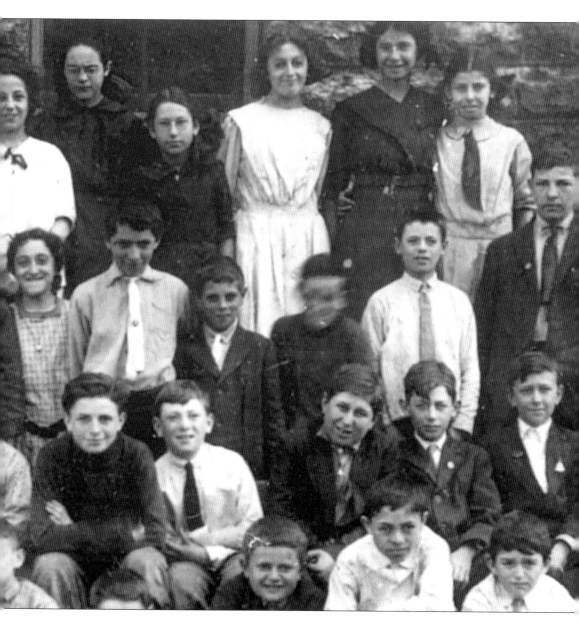

it was a long hike to school each day. The author's father, Maurice ("Whitey") Rosenblum, is located third from left in the front row. (Courtesy of the Jewish Historical Society of the Upper Midwest.)

Located at 145 Fenton, the original Lafayette School sat behind the B'nai Zion Synagogue. It was constructed in 1876. After 1882, a new addition was added to accommodate the children of the Russian and Eastern European refugees. It became so crowded that at one time it had at least 60 children in each

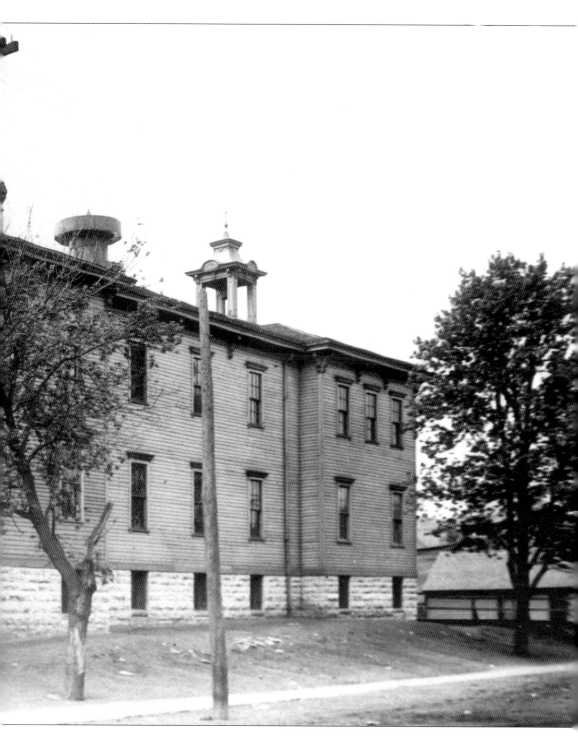

classroom. The parents of the children met at the Talmud Torah and pressed for a new building, which was constructed in 1923. (Courtesy of the Minnesota Historical Society.)

The "new" Lafayette School constructed in 1923 replaced the original school, which dated back to 1876.
It was a longtime fixture on the West Side Flats for several generations until it, too, was torn down in the

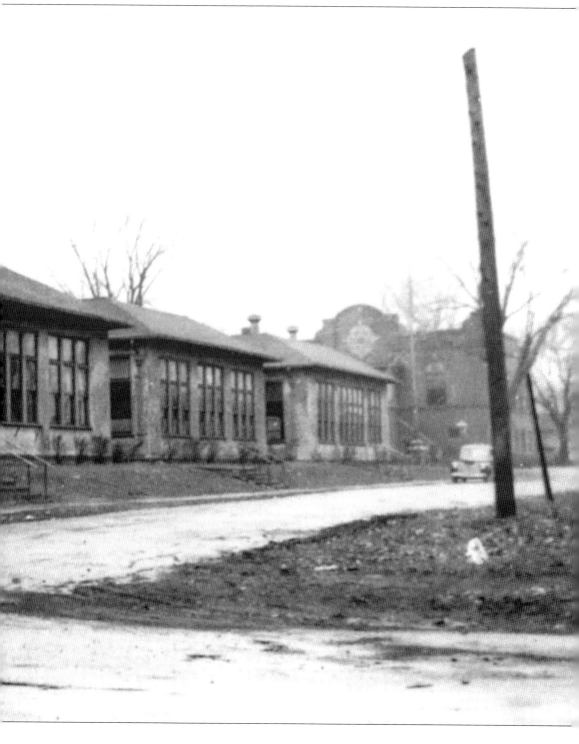

1960s for "urban renewal." Behind the school can be seen the Talmud Torah. (Courtesy of the Jewish Historical Society of the Upper Midwest.)

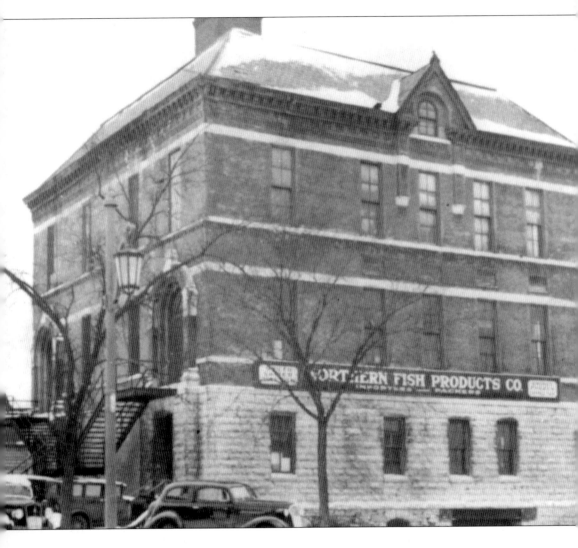

Originally called the Humboldt School, this building was constructed in 1879, and housed over 650 students. It was located in the West Side Hills at South Robert and Colorado Streets. Two additional units were added after the arrival of many more Russian and Eastern European refugees in 1884 and again in 1887, and the original building was eventually demolished. In 1888, the first high school on the West Side was constructed, named Humboldt High School, while this building was renamed the Edison School. In 1911, the St. Paul School board created the "continuation" school, for children under the age of 16 who had to work, and moved them into the Edison School. It housed approximately 280 students in 6 classrooms. In 1930, the building was sold. (Courtesy of the Minnesota Historical Society.)

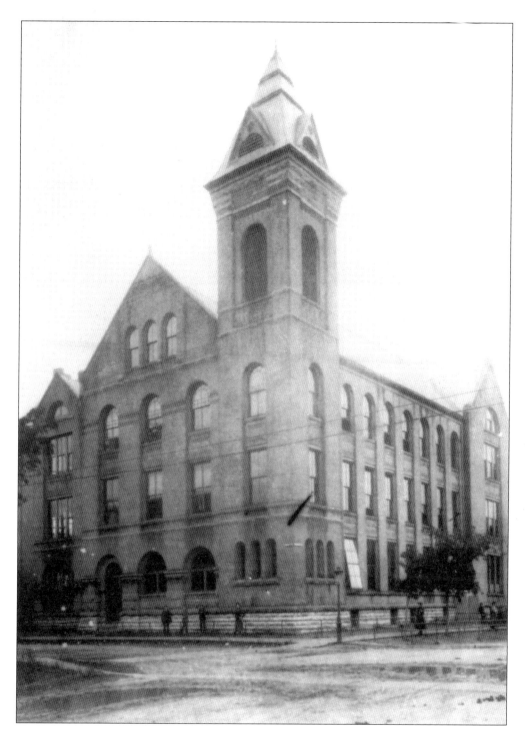

Constructed in 1888 as the first high school in the West Side, this building served as Humboldt High School until 1911, when it was converted into Crowley School. Located in the West Side Hills, it was a long trek for high school students living in the West Side Flats. (Courtesy of the Minnesota Historical Society.)

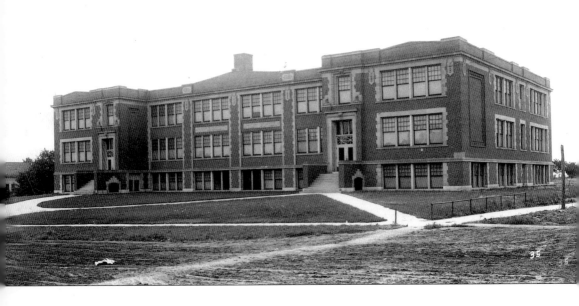

Humboldt High School is seen here shortly after it opened up in 1915 for students of high school age in the West Side Flats. It was located in the West Side Hills, requiring a one hour walk for those that lived in the West Side Flats. (Courtesy of the Minnesota Historical Society.)

VII.

Old Man River

One of the first things that the refugees learned as they settled into living on the West Side Flats was that come spring and Passover, there would also come the annual flooding of the Mississippi River. The river had no other place to go after the winter snows melted, due to its location on low, flat, sandy ground. Land next to the river was marginal and cheap, and so it attracted the city's newer immigrant groups. And it was this flood plain of the West Side Flats where the Russian and Eastern-European Jews settled. (102)

There were some advantages to dwelling on the unstable soil next to the river. They could walk across either the Wabasha Street Bridge or the Robert Street Bridge for jobs, or they could drive their horses and junk peddler wagons to areas full of promising pickings. (103)

It was a challenge to live on the Flats. All of the furniture on the first floor of their modest frame homes had to be moved to the second floor during the flooding. Boards were used as bridges from one second-story window to another, making a temporary "skyway" through the community. (104)

The high waters of the river crept slowly over the lowest-lying streets: Plato, Chicago, Eaton, Minnetonka, Constance, Fenton, Kentucky, and Texas. (105) Many of the residents loaded their belongings onto flatboats and waited for the muddy waters to recede. The wooden sidewalks (there were no cement sidewalks) floated away, and would later be grappled for kindling wood. Many fished for carp and other fish from their second story windows. (106)

Everything was damp, and nothing could be kept in the cellar, unless it was tied down. People could not get to work, and those closest to the low ground had to wear high boots.

As the water receded it left mounds of sand that built up the streets that were already above the levels of the houses. Even the synagogues were not immune. Before the arrival of funeral homes and undertakers, the synagogues often stored rough built wooded caskets in their basements to be used as needed by the community. As the flood waters came, the caskets that were stored in their basements often floated out. (107) It was not

uncommon to see rowboats seeking out and recapturing errant caskets and towing them back from whence they came.

It was often said that most of the simple frame houses did not have running water, but that the water ran down their streets. The capacity of people to survive these annual inundations and inconveniences is reflected in the fond memories of those who grew up on the West Side Flats. (109)

To many of the Eastern European Jews on the West Side Flats, however, the river seemed to be a barrier to a better life among the more established German Jews living on the east bank of the river.

By the 1920s the Minnesota State Health Department would label the Mississippi River at St. Paul and particularly around the West Side Flats as a health hazard. The location of the State Street Dump meant contamination got into the river water and bred disease. The Great Depression hit before anything could be done. (110)

The flooding of the Mississippi River in April of 1952 was the worst flood of the century, submerging most of the West Side Flats under water. (111) The basements of the synagogues were completely flooded, and it took a rowboat to get to the Talmud Torah. The levees then in existence were totally inadequate to the task of holding back the river, and most West Side Flats residents were forced to abandon their homes. (112)

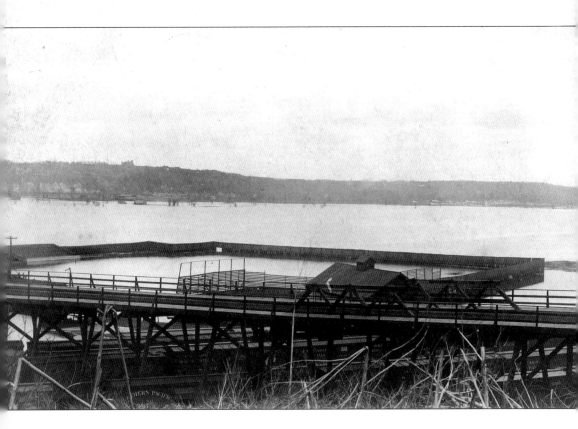

The State Street Ball Park can be seen submerged during the spring flooding of 1890. In the foreground can be seen the so-called "State Street" bridge leading to the higher ground of the West Side Hills and West St. Paul. (Courtesy of the Minnesota Historical Society.)

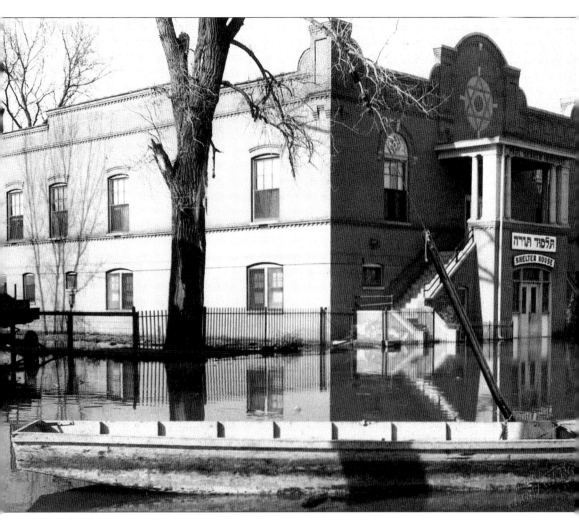

The floods of the spring of 1952 were the worst the West Side Flats ever endured. This scene shows the Talmud Torah under water. Notice the flat boat seen in the picture. (Courtesy of the Jewish Historical Society of the Upper Midwest.)

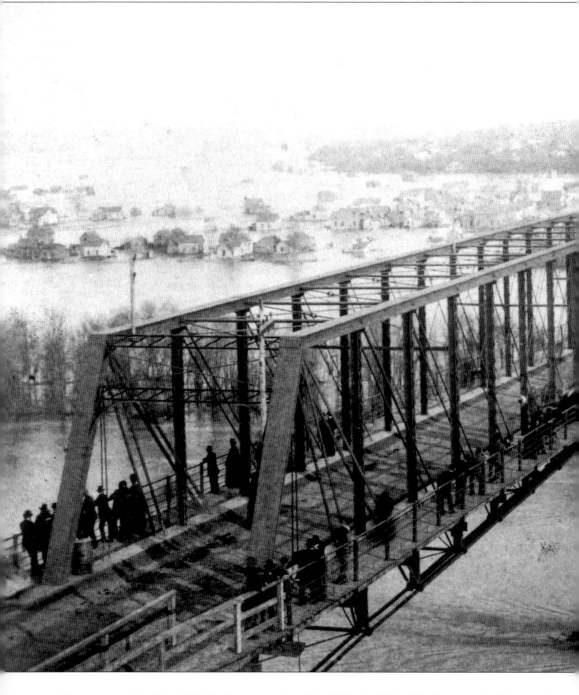

The same year that Czar Nicholas II was assassinated in 1881, the West Side Flats sustained its annual spring flooding. This photo by C.N. Zimmerman was taken from the downtown side of the Wabasha Street Bridge looking towards the Flats. This bridge was at the time the only way to get to the other side of the

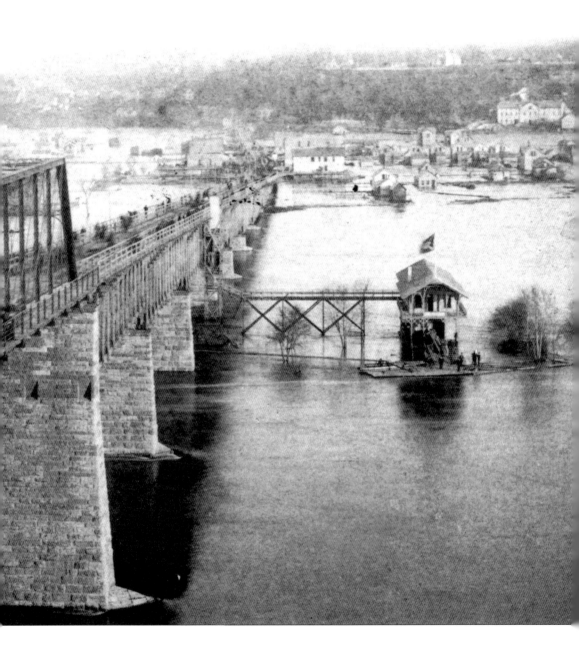

Mississippi River, until the Robert Street Bridge was constructed in 1886. (Courtesy of the Minnesota Historical Society.)

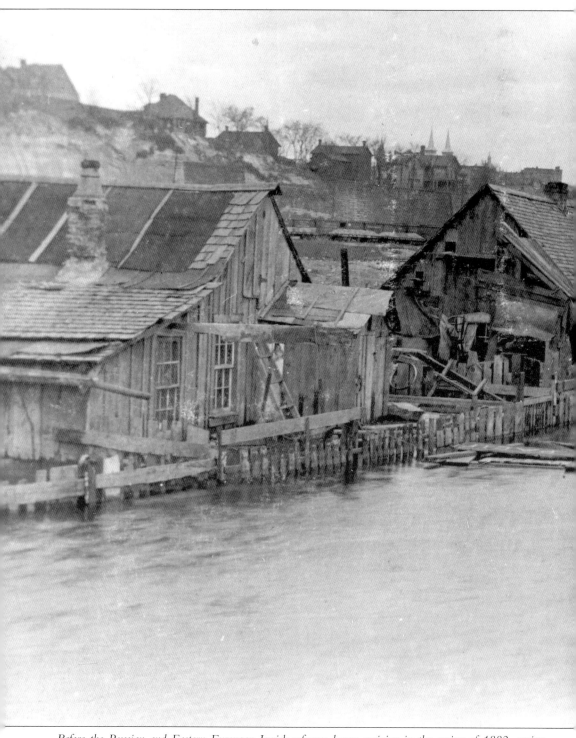

Before the Russian and Eastern European Jewish refugees began arriving in the spring of 1882, spring flooding was common on the West Side Flats. This scene shows the annual flooding of the Flats during the

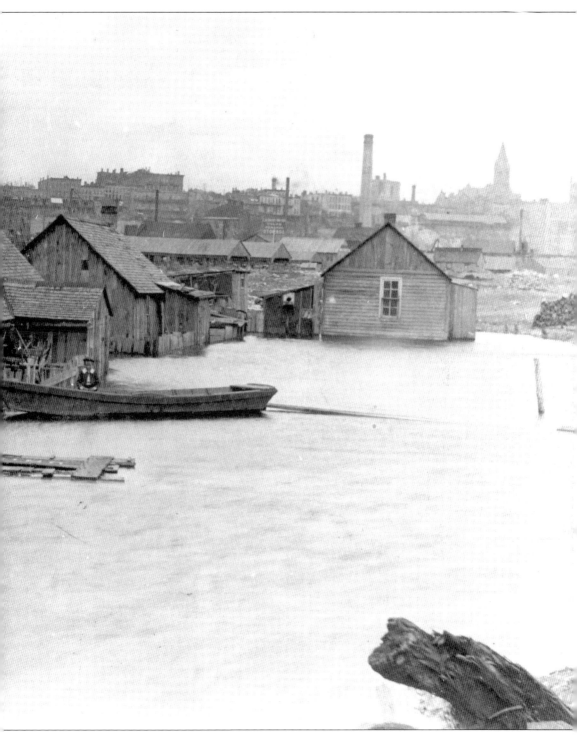

spring of 1880. (Courtesy of the Minnesota Historical Society.)

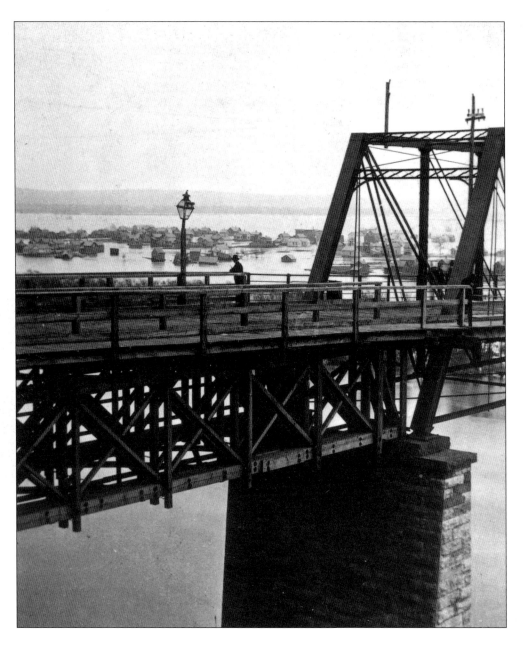

The flooded West Side Flats were being observed during the spring of 1885 from the Wabasha Street Bridge by sightseers, as shown here. (Courtesy of the Minnesota Historical Society, photo by M. Nowack.)

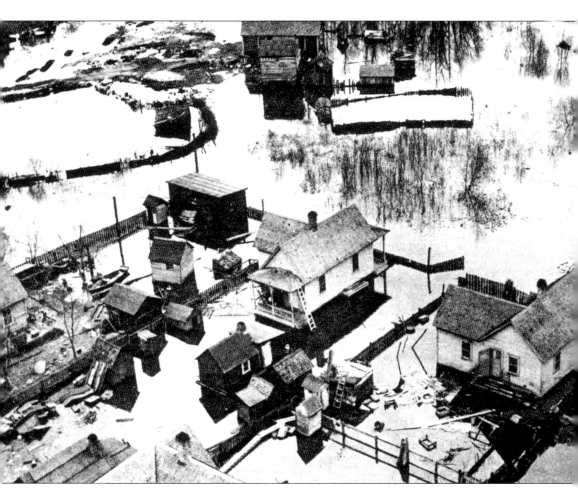

The devastation to the West Side Flats during the annual spring flooding can be clearly seen in this birds-eye view taken in 1916. By then many of the Russian and Eastern European Jewish refugees had had enough, and once they could afford to, they moved to the West Side Hills or the "Hill District" around Selby and Dale Streets, or near the newly constructed Temple of Aaron at Ashland Grotto Streets. (Courtesy of the Minnesota Historical Society.)

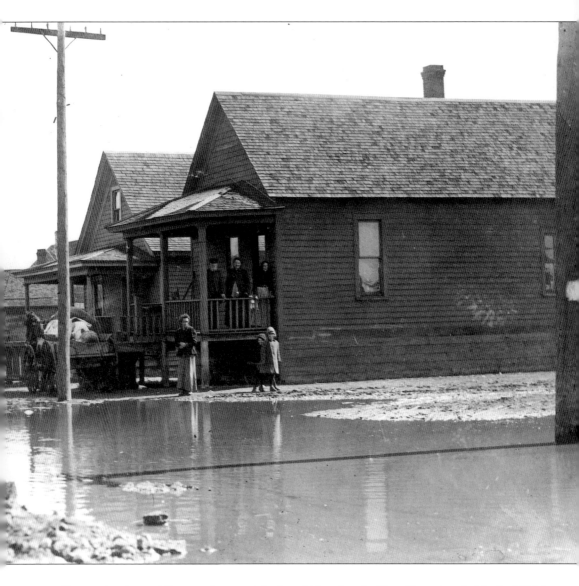

Come spring-time and Passover, the annual flood would inundate the Flats. Shown here in March of 1916, the flooded street has reached up to the homes, while a horse and wagon are parked just out of the water's reach. (Courtesy of the Minnesota Historical Society.)

VIII.

Goodbye

As the world of 1910 faded into history, horses and wagons were replaced by cars and trucks. Home heating was converted to oil. Blacksmiths, feed dealers, and the men in the white coats who cleaned up after the horses were no longer needed. The refugee generation began to pass away, and a new generation replaced the old.

Some of the more prosperous refugees and their descendants began to follow the German Jews to the Hill District around Dale and Selby Streets to organize the Temple of Aaron on Ashland and Grotto Streets. But the West Side Flats Jewish community remained strong, and by 1915 almost 72 percent of the West Side Flats continued to be Jewish, with about 463 families. (113) After World War I, descendants of the early refugees continued the slow trek out of the West Side Flats, to be replaced by newer Jewish refugees, Lebanese, Syrians, and Hispanics.

World War I had come and gone, and the Jewish community had contributed its share of casualties.

By the 1920s, the first phase of the Russian-Jewish immigration had ended. The arrival of new immigrants from Europe had stopped in 1924, with the enactment by the United States Congress of restrictive entry laws. (114)

The year 1920 marked a decisive turn in the status and fortunes of the Jews on the West Side Flats. Life on the West Side Flats was improving for its Jewish residents. Jewish-run stores and businesses were modernized and enlarged. Restaurants, movie houses such as the New Ray Theater, and modern drug stores began to appear. (115) Larger and more modern houses to accommodate the large and growing Jewish families were constructed to replace the old shanties that the refugees had lived in. (116)

The descendants of the refugees had also begun to move to the West Side Hills across the State Street Bridge. The Hills were on higher ground and away from the floods that inundated the Flats. There they organized the Beth David synagogue.

The Depression of 1929 had a devastating effect on the West Side Flats, as well as on the rest of the country. They were hard times with neighborhood pool halls filled with idle hands

A long view down State Street from the corner of Texas Avenue is shown here. Everything in this picture was demolished, including the streets and sidewalks, to make way for an industrial park. (Courtesy of the Minnesota Historical Society, photo by Tino Avaloz.)

and great schemes. (117) A branch relief office opened in the Neighborhood House and almost 150 people per day were taking free showers in the gymnasium. The library in the Neighborhood House was filled with activities of all kinds that dulled the desperation that shrouded the Flats.

The number of Jewish families on the West Side Flats remained constant at about 447, but by 1930 they made up only 36 percent of the population there, due to the influx of a multitude of other and newer immigrants. (119) The community remained stable, and many descendants of the refugees chose to remain in their close-knit community. Many Jewish businesses remained and stabilized the community, and the synagogues remained strong forces.

By 1941, however, the drift of Jews out of the West Side Flats had continued to the point that the newer Mexican-American residents exceeded the Jewish population. (120) With the United States' entry into World War II, the movement of Jewish families out and Mexican-American families in accelerated. (121) Also, many people from rural parts of Minnesota moved into the cities seeking work in the defense plants, and some of them moved into the West Side Flats. (122)

With the economic recovery of the post-war years, many more Jewish families found it

As the residents of the West Side Flats prospered, they constructed more modern stores to accommodate their needs. Shown here is a grocery store building on State Street. On the left side of the store can be seen a customer being waited on and various grocery items displayed in the window. The owner of the store usually lived over the store with the family. All of these buildings were torn down for the "urban renewal" of the 1960s. (Courtesy of the Jewish Historical Society of the Upper Midwest.)

Not all of the homes on the west Side Flats were "shanties." This home at 345 Kentucky Street was a more typical house, but it too was demolished in the 1960s. (Courtesy of the Jewish Historical Society of the Upper Midwest.)

economically possible to move out, including many of those who had moved to the West Side Hills. They all headed to Highland Park in the southwest part of St. Paul, which was also close to the Mississippi, but on much higher ground. (123)

The early 1950s saw most of the remaining Jewish families leave the Flats, especially after the floods of 1952, although many Jewish businesses remained on the Flats, and many older Jewish residents chose to remain close to their synagogues. (124) These elderly Jews wanted to live out their lives close to familiar surroundings. Throughout the 1950s the synagogues remained open for the High Holidays of Rosh Hashana and Yom Kippur, and many of the children and grandchildren came down to the Flats to worship with their grandparents because it was traditional. (125)

In 1956, less than 75 years after the first Jewish refugees had fled Russia, Lithuania, and Poland, the Jewish community learned again with horror that they had to leave. The St. Paul city fathers, through the Port Authority, decided that it was time to abandon this low lying floodplain, and to construct flood walls and an Industrial Park to boost the city's tax base. Everything in the 320 acre area known as the West Side Flats had to go. (126) There was some community opposition, but it was poorly organized. The best that some of the remaining Jews could do was to retrieve some of the street signs marking State and Texas Streets. (127)

The only difference between the flight from Russia, Lithuania, and Poland in 1882 was that these Jews would be paid modest sums for their homes. People who owned small businesses were facing the same problem as the home owners. The money offered them for their property was often not enough to relocate elsewhere. (128) There also were the

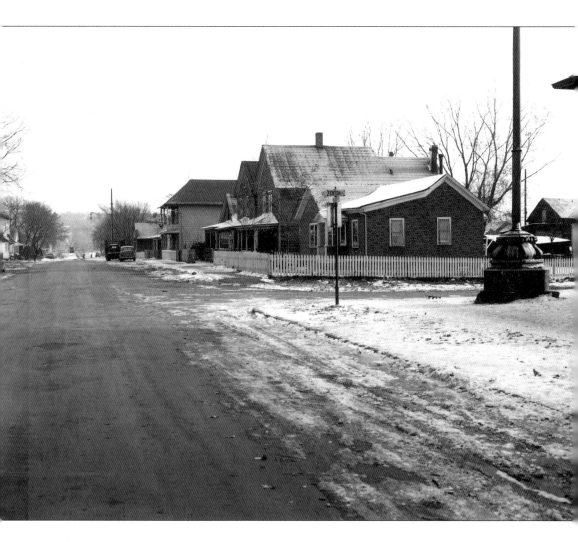

Shown here is a street scene on the south side of Kentucky Street between Fenton and Minnetonka, across from the Talmud Torah building, in 1940. All of these homes were torn down to make way for an industrial park in 1962. (Courtesy of the Minnesota Historical Society.)

buildings that could not be relocated at all: the synagogues and the Talmud Torah. (129)

As Bill Hoffman commented in his book *West Side Story II*, "There once was a time when a wrecking would have been an event of tremendous significance. For one thing. . .there was the free lath and scrap lumber to be salvaged for uses such as heating and little repairs to the barn and the chicken coops, and sometimes, even to build a shack." (130) In his chapter called "The Last House on Texas Street," he writes, ". . . I knew this house and the people who lived and died in it, just as I had the others (that were torn down). . . . I remembered each room, each piece of furniture and even the wall paper." (131) This urban renewal project was to eliminate every trace of every Jewish family, their homes that they raised their children in, the synagogues that they prayed in, the stores that they had shopped in and even the streets that they had walked on. (132)

Just as the Russian holocaust had destroyed centuries of Jewish life and community, the demolition of the West Side Flats would wipe out the new Jewish world into which they had moved. Oliver Town, a Gentile, who wrote a column for the *St. Paul Dispatch* commented, "I stood in the intersection of Fairfield and Robertson in the ominous silence and the smell of death all around. The death of a neighborhood. The only sound was the flapping of an unhinged, rusting door on a house." (133)

The last synagogue service on Fairfield was held in October of 1962. The last family was moved out in January of 1964 when the last building was demolished, and "standing at the corner of State and Fairfield, one encountered only the flat and level land stretching to the river and an eerie stillness." (134)

Gerr's Kosher Meat Market, a long-time fixture on the corner of State Street and Texas Avenue, is shown here in 1960. (Courtesy of the Minnesota Historical Society, photo by Tino Avaloz.)

This is a street scene across from the B'nai Zion Synagogue located at 150 State Street. It was taken in 1959, before the entire area was leveled to build an industrial park. On the corner can be seen a grocery store or a meat market. (Courtesy of the Minnesota Historical Society.)

Fires were frequent on the West Side Flats, because of the many wood-frame houses, but the fire service, such as it was, was quick. Shown here is a major fire at the Birnberg residence at 170 Eaton Street on October 24, 1937. (Courtesy of the Minnesota Historical Society.)

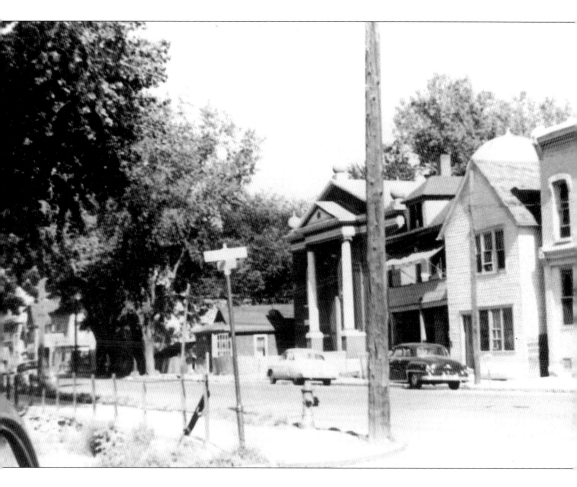

The corner of Eva and Fairfield in 1950 was the heart of the "old" West Side Flats. Pictured with the pillars is Agudah Achim (Russian Brotherhood) Synagogue, one of the major synagogues of the Flats originally constructed in 1902. All of these homes and buildings, including the synagogues, were demolished; nothing remains, not even the streets. (Courtesy of the Minnesota Historical Society.)

Abe Goldberg's "shop" was located at 290 Alabama Avenue near State and Fillmore Streets, on one whole block surrounding this modest building, which was constructed in the early 1900s. A loft in the large shed on the property had pigeons, and occasionally the Goldbergs had squab for dinner. When the city fathers decided to level everything on the West Side Flats in 1962, this building was no exception. (Courtesy of Josephine Berg Simes, his granddaughter.)

APPENDIX

The Peddlers

In the 1910 Polk City Directory, the following were listed as peddlers:

Jacob Brussel	108 1/2 State Street	Joseph Rosenblatt	156 State Street
David Bashetfin	157 State Street	Max Silver	156 State Street
Himan Berkowitz	237 State Street	Benjamin Tankenoff	133 State Street
David Berkus	255 State Street	William Tankenoff	102 State Street
Harry Berkus	224 State Street	Nahum Schekter	198 State Street
Morris Berman	210 State Street	Morris Abramofsky	231 E. Fairfield
Meyer Black	156 State Street	David Elfenbein	225 E. Fairfield
Joseph Bratter	159 State Street	Louis Harris	242 E. Fairfield
Louis Cohen	221 State Street	Samuel Kaminetsky	164 E. Fairfield
William Cohen	237 State Street	Samuel Kaplan	172 E. Fairfield
Peter Cohn	220 State Street	Henry Serbine	245 E. Fairfield
John Eurist	188 State Street	Louis Smith	154 E. Fairfield
Michael Feldman	100 State Street	David Whitefield	159 E. Fairfield
Louis Friedman	201 State Street	Benjamin Applebaum	293 Kentucky
Albert Goldberg	201 State Street	Jacob Applebaum	270 Kentucky
Jacob Goldstein	88 State Street	Louis Applebaum	270 Kentucky
Fishel Gotlieb	92 State Street	Jacob Butwinnick	281 Kentucky
Philip Gotlieb	83 State Street	Samuel Cohn	326 Kentucky
Isadore Hartman	216 State Street	Louis Feldman	327 Kentucky
Morris Hartman	216 State Street	Meyer Frank	324 Kentucky
Joseph Hervitz	198 State Street	Moses Harris	329 Kentucky
Harry Kaufman	249 State Street	Harry Kaplan	310 Kentucky
Hyman Sanderson	259 State Street	Israel Keller	281 Kentucky
Hymen Sanderson	237 State Street	William Rutzick	328 Kentucky

Max Bloom	158 E. Indiana	Jacob Singer	261 Texas
Jacob Halper	26 W. Indiana	Frank Barenbaum	159 Eva
Michael Halper	26 W. Indiana	Joseph Beresky	135 Eva
David Katz	162 W. Indiana	Morris Berkowitz	141 Eva
Samuel Katz	181 E. Indiana	Samuel Bernstein	163 Eva
Samuel Rosen	203 E. Indiana	Joseph Goldman	139 Eva
Harry Baskin	178 Robertson	Morris Koretsky	165 Eva
Max Cohen	145 Robertson	Nathan Weiner	137 Eva
Max Goldberg	172 Robertson	Victor Berkowitz	170 E. Chicago
Bernard Harris	131 Robertson	Abraham Charntsky	199 E. Chicago
Morris Keller	136 Robertson	Samuel Charntsky	199 E. Chicago
Max Kramerman	154 Robertson	Himan Kaplan	182 E. Chicago
Aaron Margulis	102 Robertson	Israel Rosenberg	164 E. Chicago
Hanry Mark	180 Robertson	Jacob Mark	177 E. Chicago
Abraham Smith	165 Robertson	Harry Tennenbaum	175 E. Chicago
Isaac Tennenbaum	136 1/2 Robertson	William Winer	182 E. Chicago
Louis Warshausky	137 Robertson	Joseph Abesy	215 E. Fillmore
Maurice Blehart	130 Eaton	Haymy Charnoff	240 E. Fillmore
Nathan Cohen	158 Eaton	Jacob Goldstein	321 St. Lawrence
Jacob Green	132 Eaton	Max Greenstein	320 St. Lawrence
Joseph Kirovitch	128 1/2 Eaton	Joseph Greenwald	321 St. Lawrence
Isaac Schwartz	126 Eaton	Samuel Tankenoff	332 St. Lawrence
Israel Applebaum	280 Texas	Samuel Abrass	197 S. Wabasha
Harry Berkowitz	321 Texas	Himan Berkowitz	227 Plato
Morris Bloom	283 Texas	Morris Goldberg	229 Plato
Moses Chase	315 Texas	Jacob Weiner	223 Plato
Isaac Frank	319 Texas	Harry Finkelstein	149 Fenton
Samuel Goldberg	308 Texas	Joseph Fryer	146 Fenton
William Goldstein	308 Texas	William Goodman	147 Fenton
Samuel Gransberg	263 Texas	Wolf Gutman	147 Fenton
David Greenstein	320 Texas	David Halper	207 Fenton
Abraham Mark	287 Texas	Max Goldstein	121 Minnetonka
Harry Singer	261 Texas	Nathan Brodsky	275 Tennessee
Herman Singer	261 Texas		

Bibliography

Castle, Henry. *History of St. Paul and Vicinity*, 1912.

Carson Map Co. *Plat Book of the City of St. Paul*, 1960.

Dimont, Max. *Jews in America*, 1978.

Empson, Donald. *On the Street Where You Live*, 1975.

Ervin. *The Twin Cities Perceived*, 1976.

Frankel, H.D. "History of St. Paul Jewish Community," *Reform Advocate*, 1907.

Geer, Everett S. *1884 Street Guide*, 1884.

Heibert, Gary. "Oliver Towne Column," *St. Paul Dispatch*, February, 1962.

Hoffman, William. *Mendel*, 1969.

Hoffman, William. "A Proud Era is Gone," *American Jewish World*, September, 1962.

Hoffman, William. *Tales of Hoffman*, 1961.

Hoffman, William. *West Side Story, II*, 1981.

Hopkins, G.M. *Atlas of the Environs of St. Paul, Minnesota Including the Whole of Ramsey County, Minnesota*, 1886.

Jewish Immigration, 1881–1924. 1940.

Kunz, Virginia Brainard. *St. Paul, Saga of an American City*, 1977.

Lewin, Rhoda. *Jewish Community of North Minneapolis*, 2001.

Mackay, Jack B. "Fifty Years of St. Paul Jewry," *American Jewish World*, September, 1962.

Millett, Larry. *Lost Twin Cities*, 1997.

Millett, Larry. *Twin Cities; Then and Now*, 1996.

Neighborhood House Annual Reports, 1914–1941.

Olitsky, Kerry M. *The American Synagogue*, 1996.

Pierce, Lorraine. *The Jewish Settlement on St. Paul's Lower West Side*, University of Minnesota Library, 1976.

Plaut, Rabbi Gunther. *The Jews in Minnesota*, 1959.

"Polk City Directory," *1885, 1910, 1927.*

Rosenblum, Gene H. *Jewish Pioneers of St. Paul, 1849–1874*, 2001.

Rutzick, Mark C. *From the Village of Ruchki*, 1998.

Sigvertsen, Jene T. *An Inventory of St. Paul Schools, Past and Present*. Minnesota Historical Society Library.

St. Paul Public Works Department. *A Guide to St. Paul Streets before 1937*, Minnesota Historical Society Library.

Towne, Oliver. *St. Paul is My Beat*, 1958.

Watson and Co. "Classified Business Directory," 1899-1900.

Williams, Fletcher. *A History of St. Paul to 1875*, 1983, reprint.

Annotations

1. *A History of St. Paul to 1875*, J. Fletcher Williams (1983 reprint), page 12. For a very interesting review of the geological forces that shaped both Ramsey County and the Mississippi River, see "The Geological Forces that Shaped Ramsey County and the People who Followed," *Ramsey County History* (1999), pages 4–7. Ramsey County Historical Society.

2. *Ibid.* page 237.

3. *Ibid.* When it was finally approved, the ferry plied the waters between the two shores until the new bridge was completed.

4. *St. Paul, a Saga of an American City*, Virginia Brainard Kunz (1977), page 57.

5. *A History of St. Paul to 1875,* Williams, (1983 reprint), page 378.

6. *Ibid.* pages 448-449.

7. *St. Paul, a Saga of an American City*, Virginia Brainard Kunz (1977), page 191. In 1926, the city of St. Paul purchased an additional 2,312 acres of the West Side Flats for the downtown airport.

8. *Jews in America*, Max Dimont (1978), page 160.

9. *Ibid.* page 148.

10. *Ibid.*

11. *Ibid.* page 150.

12. *Ibid.* page 160.

13. *Ibid.* page 162.

14. *Jewish Pioneers in St. Paul, 1849–1874*, Gene H. Rosenblum (2001).

15. *The Jews in Minnesota*, Rabbi Gunther Plaut (1959), pages 91–95. A comprehensive review of those days in 1882 is contained in Rabbi Plaut's vivid description of the plight of the early Jewish refugees.

16. *Ibid.*

17. *Ibid.*

18. *Ibid.*

19. *Jews in America*, Dimont (1978), pages 162-163.

20. *Ibid.*

21. *Jews in Minnesota*, Plaut (1959), page 94. See notes 13, 14, and 15 on page 94.

22. Polk's St. Paul City Directory.

23. *Ibid.*

24. *The Jews in America*, Dimont (1978) page 162. See also *Tales of Hoffman*, William Hoffman (1961), page 63, for a description of the efforts to bring over the families that were left behind.

25. *The Street Where You Live*, Don Empson (1975); *Guide to St. Paul Streets Before 1937*, St. Paul Department of Public Works; "1884 Street Guide," Everett S. Geer (1884).

26. *Ibid.*

27. *Ibid.*

28. *West Side Story, II*, William Hoffman (1982); see also Polk's St. Paul City Directories, 1885–1910.

29. *Ibid.*

30. *Ibid.*

31. *Ibid.*

32. *Guide to St. Paul Streets before 1937*, St. Paul Public Works Dept.; *On the Street Where You Live*, Empson (1975).

33. *West Side Story, II*, Hoffman (1982). See all of William Hoffman's books that provide memories of the Old West Side Flats: *Mendel* (1969); *Those Were the Days* (1957); *Tales of Hoffman* (1961).

34. Polk's St. Paul City Directory (1885).

35. *On the Street Where You Live*, Empson (1975).

36. *West Side Story, II*, Hoffman (1982).

37. *Ibid.*

38. *Jews in America*, Dimont (1978).

39. *Ibid.*

40. *Mendel*, Hoffman (1969). Hoffman's vivid descriptions of life on the "West Side Flats" indicate that the Jewish immigrants who first settled on the Flats were too busy scraping a living together to even give much thought to pursuing any formal education for themselves.

41. *Ibid.* See also Polk's St. Paul City Directories (1907, 1910) for the various occupations they eventually settled into.

42. *Ibid.*

43. *Mendel*, Hoffman (1969).

44. *Ibid.*

45. Polk's St. Paul City Directory (1910).

46–50. *Ibid.*

51. Polk's St. Paul City Directory (1910).

52–63. *Ibid.*

64. 1910 was the year that the "West Side Flats" reached its zenith. It was a flourishing and bustling community. Its Jewish population had reached the point that 72 percent of the 650 families were Russian-Jewish according to the study by Neighborhood House, with an average of six members per family. *Neighborhood House Annual Reports* (1916–1941). Also see *West Side Story II*, Hoffman (1981), page 12. By the 1920s, the United States Congress had cut off any further growth with its restrictive immigration policies, and as the Jewish community flourished, its members began to move out of the Flats to higher ground in the West Side Hills, the Capitol Heights area around Fourteenth Street, and the Cathedral Hill district, west of the new Roman Catholic Cathedral.

65. See *West Side Story II*, Hoffman (1981), pages 7–16 for a history of the creation and development of the Neighborhood House, first on the West Side Flats, to meet the needs of the Jewish refugees and then later, as a community-based, non-sectarian facility serving the entire West Side, and West Side Hills, when it moved there in the 1920s. Also see *Neighborhood House, 1897–1947*, (1947).

66. *The Jews in Minnesota*, Plaut (1959), chapter on "Women of Valor," pages 152–155. This is an inside view of the creation and then the support provided by the women of the Mt. Zion Synagogue, and especially, Mrs. Julius Austrian.

67–83. *Ibid.*

84. Also see *The Jewish Settlement on St. Paul's Lower West Side*, Lorraine Pierce (1971), a Master's Thesis, University of Minnesota Library, pages 26–27.

85. See William Hoffman's collection of memories in *Those Were the Days* (1957) and *West Side Story, II* (1981) for a description of "West Side Flats."

86–89. *Ibid.*

90. Also see H.D. Frankel's article "A History of the St. Paul Jewish Community," in *Reform Advocate* (1907), page 45. Some of his information is highly inaccurate when compared to later articles by others, but it is the only original historical data available.

91. Also see Gunther Plaut's *The Jews in Minnesota* (1959) and William Hoffman's *West Side Story, II* (1981).

92–97. *Ibid.*

98. See Kerry M. Olitsky's *The American Synagogue* (1996), pages 186–187. This provides a brief history of some of the synagogues throughout the United States.

99. *West Side Story, II*, Hoffman (1981).

100. *Ibid.*

101. *West Side Story, II*, Hoffman (1981). Also see *An Inventory of St. Paul Schools, Past and Present*, Jene Sigvertsen (1994), Minnesota Historical Society Library. For more information on the development of the "continuation school" by the St. Paul Schools see *History of St. Paul and Vicinity*, Henry Castle (1912) in his review of the history of the St. Paul school system in its efforts to relieve the crowded schools in about 1911.

102. Even today, with all of the engineering, the Mississippi River still floods at this point of the river. Many have written about these floods including Don Boxmeyer in his newspaper columns in the *St. Paul Pioneer Press* on March 20, 2000, a copy of which he has kindly provided me. Also see *St. Paul, the Saga of an American City*, Kunz (1977).

103. *Those Were the Days*, Hoffman (1957). In his reminiscences, in the early part of his book, the Mississippi River offers a stark contrast to the Jewish refugees who settled on the lower East Side of New York City.

104–107. *Ibid.*

108. *West Side Story, II*, Hoffman (1981), pages 36–37.

109. *Those Were the Days*, Hoffman (1957).

110. *Ibid.*

111. *Ibid.*

112. *Ibid.* Also see *The Twin City Personal, a Study in Words and Drawings*, Ervin (1976), pages 70–72. In 1956, the St. Paul Port Authority announced plans to acquire the "West Side Flats" for the Riverview Industrial Park. All of the residents and businesses were forced to sell and an entire community was uprooted.

113. *Neighborhood House Annual Reports, 1914–1915*, page 15.

114. *From the Village of Ruchki*, Mark C. Rutzick (1998). Also see "Fifty Years of St. Paul Jewry," *American Jewish World*, Jack B. Mackay (September, 1962).

115. *West Side Story, II*, Hoffman (1981).

116. *Ibid.*

117. *Ibid.*

118. *Neighborhood House Annual Reports, 1931.*

119. *From the Village of Ruchki*, Mark C. Rutzick (1998), page 63.

120. *Neighborhood House Annual Reports, 1941.*

121. *The Jewish Settlement on St. Paul's Lower West Side*, Lorraine Pierce (1971), a Master's Thesis, University of Minnesota Library, pages 73–74. Also see "Fifty Years of St. Paul Jewry," *American Jewish World*, Jack B. Mackay (September, 1962).

122. *Ibid.*

123. *From the Village of Ruchki*, Mark C. Rutzick (1998), page 68.

124. *The American Synagogue*, Kerry M. Olitsky (1996), page 186.

125. *Ibid.*

126. *West Side Story, II*, Hoffman (1981), page 21.

127. *Ibid.*

128. *From the Village of Ruchki*, Mark C. Rutzick (1998).

129. Thus, the heart and soul of the Jewish community were the last to go.

130. *West Side Story, II*, Hoffman (1981), pages 44–45.

131. *Ibid.*

132. "Oliver Towne Column," Gary Heibert, *St. Paul Dispatch* (February 14, 1962).

133. *Ibid.*

134. Noach Meckler led the last service on that Yom Kippur day of 1962, marking the end of the Jewish community of the "West Side Flats."